At the Edge of the World

TOPOGRAPHICS

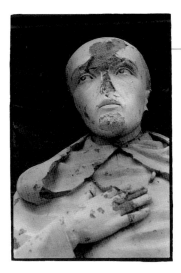

Jean Mohr/John Berger

At the Edge of
the World

REAKTION BOOKS

Published by Reaktion Books Ltd
79 Farringdon Road, London EC1M 3JU
www.reaktionbooks.co.uk

First published 1999

Jean Mohr's texts were translated by Mark Treharne.

Designed by Philip Lewis

Printed and bound in Great Britain by
Biddles Limited, Guildford and King's Lynn

British Library Cataloguing in Publication Data

Mohr, Jean
 At the edge of the world. – (Topographics)
 1. Photography, Artistic 2. Landscape photography
 I. Title II. Berger, John, 1926–
 778.9'36

ISBN 1 86189 048 6

Contents

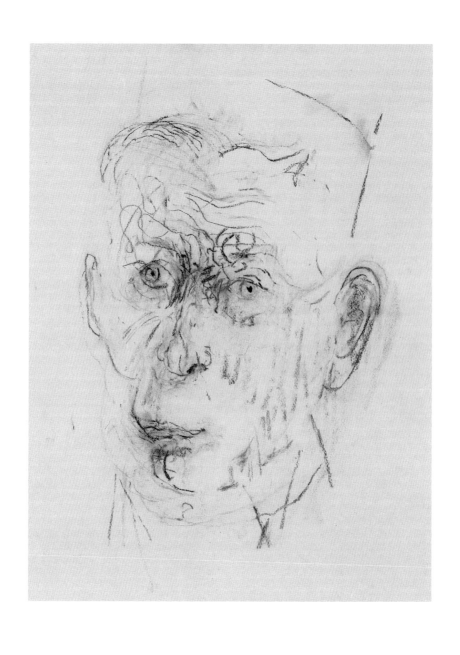

Jean Mohr: A Sketch for a Portrait

Over the 35 years of our friendship, Jean has taken many photographs of me. Sometimes, people who don't know me well propose that I write an autobiography. It's hard to explain to somebody who doesn't see it why story-tellers, as distinct from novelists, aren't very interested in autobiography. And anyway, a kind of biography, written in the laughs, the gestures, the wrinkles, the lines, the fatigue, the smiles, the grimaces, the fury to be found in the countless pictures that Jean has taken of me and that now fill how many yellow boxes? Many, of course, were taken without my realizing it, for I have become so used to seeing Jean holding up a camera in front of his broken nose that I no longer ask what he's looking at.

A few weeks ago, I decided to turn the tables on him.

'Will you pose for me?' I asked.

'Can I bring my camera?'

'Of course,' I said.

And so Jean came and posed for several hours while I tried to draw him. I had drawn him once before – about five years ago – but I had forgotten that drawing, and I didn't want to look at it again for the moment.

In the studio, we listened to music (Jean shared with his father a love of Mahler, Schubert, Berg), and when the music stopped, we talked about how it felt to be 70 years old, and we remembered old friends, some of them lost, and we named old loves, and all the time, throughout the music or the talk or the silences, I was trying to read the face of this man with whom I had learned so much, and with whom I had been to many places for the first time.

At about the same time as I was doing this drawing, my daughter Katya, unbeknownst to me, was writing a letter to Jean:

> Like everybody else, I first of all notice your eyes. They are so pale that they become as if black – in the same way that a mountain

stream can be so cold that it burns you. Like two stars that do something to the night sky, and you can't tell whether they are two holes piercing a black canvas or whether they are the only things that are solid in the great emptiness above. In other words: are your eyes shooting out light or breathing it in? Anyway, the diaphragm of your pupils, Jean, is perfectly adjusted before you flick your eyelids.

There is certainly an electrical charge in your eyes. At times violent.

And then, in contrast, there is the skin of your face, so serene, naked. Both a triumph and a vulnerability. Not the slightest movement of either coming towards or drawing back is visible on its surface. Your skin is simply there: a given. Like the skin of a newborn, so fresh that the smallest drop of perspiration would be visible on it. Soft almost to the point of glistening. Untouchable. Enviable. Like the skin of a fish that has never been drawn because it has never been caught.

And I have the impression that it is from the balancing act between the high tension of your eyes and the 'earth' of your skin that you get a lot of your strength.

So, there's a kind of harmony in you. The sharp and the velvet are combined in order to persuade the look of something to come out of its lair so that, old fox that you are, you can snap it in one.

I was drawing with charcoal on large sheets of Ingres paper, about life-size. I did three drawings, all of them bad, but becoming perhaps a little less bad. At the beginning, all you can do is make a clumsy map of the face. Three and a half maps.

Finally, it was time for him to leave. He settled into the driver's seat, raised two fingers of his left hand like a pilot before taxiing onto the runway, and said: 'It was good to be together.' Then he drove off.

I went back, took another sheet of paper and sat there, huddled over the drawing-board. Naturally, I was no longer looking at Jean, for he was no longer there. I was studying the maps on the floor and trying to forget.

When you're trying to make a portrait of somebody you know well, you have to forget and forget until what you see astonishes you. Indeed, at the heart of any portrait which is alive, an absolute surprise surrounded by close intimacy is registered. I'll certainly be misunderstood, but I'll take the risk and say that to make a portrait is like fucking.

8

After many re-beginnings, a drawing emerges. In it, I see a dog and a boy, and both are contained in the face of a man of my age. In the look of neither of them is there anything in the least naïve. (If it's naïveté you're after, you should concentrate on Successful Men.) What is here that might be mistaken for naïveté by the naïve is the habit of being startled, for the world is startling to both dog and boy. Often alarmingly, and occasionally miraculously, the world in continually startling. The photos Jean has taken all his life are the product of an alertness that comes from being startled.

I have often seen Jean with dogs, but rarely in the role of the dog's master. If he raises his voice and speaks curtly, the dog obeys him, no doubt. But this is unusual. More often, he is making dog-noises with the dog and, far from being masterly and upright, is somehow doubled up and as close to the ground as the animal. One of his books is entitled *A Dog and His Photographer*. The dog in question was called Amir and was a Persian Saluki.

I have other memories of Jean sitting with guests at a formal dinner table or drinking coffee in a drawing-room, and, without warning, because he has spotted a cat or maybe a stranger's dog through the window – he starts, without the slightest warning, to make animal or bird noises himself. His face absolutely impassive, his mouth slightly pursed yet quite still, the focus of his very pale blue eyes very far away, almost at the world's end. If there are children present, they are delighted and adopt him immediately. The adults look uncomfortable.

In the rest of his life, Jean is more than usually formal. You feel the example of his father, a highly cultivated German scholar who, because he was uncompromisingly anti-Nazi, left Germany to settle in Switzerland in the late 1930s.

I knew Jean's mother, and I've seen some of his father's library, but his father had already died when Jean and I first met. Nevertheless, I have a vivid image of his father – perhaps because Jean admired him very much. I see the way he holds himself very upright and a little stooped. I see his blue eyes half shut against the light, and I hear his modulated, calm voice.

I guess that of the six children it is Jean who resembles his father the most. Jean, however, has lived more precariously than his father did.

9

Precariously, in this context, refers to time; his father thought and felt in terms of decades or half-centuries. Jean thinks and feels in minutes or split seconds. This historical difference was encapsulated in Jean's eventual decision to become a photographer.

He might also have been a pilot. If I had to name a writer to accompany Jean in a portrait of two men, it would be Antoine Saint-Exupéry. (I say this although I'm not sure that we have ever discussed the writer, and I can guess that Jean would be sceptical about the myth surrounding the man.) Yet I see both of them as discreet, eccentric travellers, loving people and loving distances even more.

Every large family in the Alpine village where I live has its own collection of Mohr photos. Sometimes, there's one framed on the mantelpiece; others are in a box that is brought out when people start to reminisce. Frequently, these are photos they have asked him to take at a wedding, a village gathering, a dance.

Today, all the young people in the village have colour films and cameras and videos. But when Jean first started coming to visit, pictures were still rare, and a photographer was thought of as some kind of inspector or obscure State spy.

If they quickly accepted Jean and then invited him to take pictures (in exchange for illicit *eau de vie*), it was because this man who came from the ends of the world, this man with a black bag always slung over his shoulder and a slightly foreign accent and a curious love of mountains (shepherds can understand such a love better than peasants), this man, unlike an inspector, was clearly and startlingly observant all the while, as they themselves had to be because they lived unprotected lives, and it was therefore necessary to observe everything. And then, later, they found that the photos he took and gave them were a kind of company – like the tunes they knew and might sing when together. The photos became in black and white the incarnations of certain names: Théophile, Maurius, Jeanne, César, Angeline, Mares, Basil.

The other night, I had a dream about Jean. We were in a car, and he was driving. As one might expect of an airline pilot, he drives decisively and very well. At a certain moment, we stopped on a deserted road, a mountain landscape around us.

10

'Il faut tirer les photos,' he said. In French, *tirer les photos* means 'develop the photos', but, literally, it can also mean 'pull out the photos'. We opened both doors of the car, and he, having stepped outside, pulled out from under the bonnet three large photographs which were masked with adhesive paper. All three were rectangular, and one was long and narrow. As soon as I saw them, I realized that the long one had the same dimensions as the windscreen, and the other two were the size of the car's side windows.

Carefully and slowly, I pulled off their adhesive coverings. Underneath were three landscapes. I cannot really describe them, but they were beautiful, and, although the photos were black and white, I knew that they would change colour when the sun went down – in the same way that mountain snow does. In each picture, one could see something which was partly hidden under a kind of geological cornice, like somebody sheltering under eaves.

I fixed the three photos to the windscreen and the two windows. As I had foreseen, they fitted perfectly. We shut the doors, and Jean drove off. He drove with the same decisiveness as before. I did not know whether he was driving blind or with a kind of clairvoyance. But I was filled with a sense of well-being and assurance. Then I woke up.

Even among his confrères, Jean is a widely travelled photographer. He has been to many countries on the five continents, many corners of the world. Not, to begin with, to take photographs but to notice. His pictures never suggest that he was searching; rather, they suggest that he happened to be passing by. There is something strangely casual, off-hand, about his images. A kind of nonchalance. Yet a caring nonchalance. And this is precisely why one believes in the special authenticity of his photos.

Both Jean and I have a considerable admiration for Eugene Smith. Smith, however, when he set out on a reportage, was intent on finding what he was looking for, and in one way or another, he was usually looking for the same thing – a Pietà. Edward Weston was looking for a manifestation of harmony; Walker Evans for qualities of endurance. Jean, I believe, looks for nothing. What he finds is what he happens to come upon. And not infrequently, this involves somebody else looking at him!

This casualness, however, has nothing whatsoever to do with indifference; it is a simple precondition for being open to surprise. In principle, nothing surprises Jean Mohr – he has seen and observed so much; in practice, almost everything he notices surprises him because in its minute or overwhelming way, it is unique.

This is the secret of the best travellers' tales: a whispering between the familiar and the outlandish, between the banal and the unknowable, between routine and fatality. Jean's tales spare nothing and nobody, and they never judge; they often make the heart bleed, and they don't exaggerate.

I'm of course generalizing about a life's work. Jean has more than half a million photographs in his archives, and I'm trying to define the quality that makes them unmistakably his. I'm not claiming that if I was shown any one of these images I would immediately recognize it as his. But if I was shown a dozen, I think I would immediately say 'Jean!'. I would recognize them by their specific quality of surprise, a spontaneous surprise, never one which has been sought for.

The way Jean became a photographer may help to explain this. Like Cartier-Bresson and Salgado, Jean became a photographer by default. He did not set out to spend his life taking pictures with a camera.

At the University of Geneva, he studied economics and fantasized about becoming a painter. He then volunteered, in 1949, to be sent as a delegate by the International Red Cross to take care of Palestinian refugees on the West Bank and in Jordan. (Thirty years later, he would make a book about the Palestinian struggle and tragedy with Edward Said.) While on the Red Cross mission, he had the opportunity to purchase an East German camera. He bought it to give as a present to one of his brothers; then, unexpectedly, he started using it himself. He began to take pictures so as not to forget the unpredictable and incongruous details – often painful, sometimes desperate, occasionally illuminating – concerning the lives he was witnessing.

Jean returned to Europe in 1951 and settled in Paris to study painting. There he showed his Palestinian photographs to painter-friends, who found them surprising.

He decided to try portraits. Before taking out his camera, however, he would draw his sitters; they were a little nonplussed. Glancing at

the drawings, they would ask: 'What on earth are you doing? You are meant to be a photographer, aren't you?'

Consequently, bit by bit, Jean's eyes – the eyes that Katya wrote about – became accustomed to black and white, to split seconds, to the darkroom. A habit of looking-around-all-the-while, a habitual alertness, started to develop. And a demon was born.

In 1955, to earn money, he agreed to work with a couple of acquaintances who had thought up a scheme of taking aerial photographs in the countryside and then selling prints to the farmers and proprietors of the photographed land. Black-and-white, later hand-coloured by a girlfriend. In the little monoplane, Jean worked fast and under cramped conditions, but the business never got going, and the money ran out. Instead of being paid for the work he had done, he was given an enlarger and two Leicas. This is how he set up as a professional.

He began working from Geneva for different branches of the United Nations – in particular for the World Health Organization and the High Commission for Refugees. His job was to make pictures about their ongoing international projects and programmes. He was never a press or war photographer, although often his pictures, supplied by the UN, were used in newspapers.

This special freelance status – and it continued for over 25 years – allowed him to work in his own way. He was continually going to faraway places, and his travel was paid for. Furthermore, when he was on a mission, he was not under the time pressure that most press photographers have to contend with; his trips were relatively unhurried.

Consequently, apart from the reportage he delivered to the organization that had sent him, he was able to take tens of thousands of pictures for himself. These pictures were purposeless in the sense that they were not taken to prove or demonstrate a preconceived idea. They were offhand, casual, maverick, personal records of moments which astonished Jean.

Jean's work is deeply committed to what happens, and at the same time, it shows an *elsewhere*. Even when the subject is familiar to the spectator, the image will still communicate a kind of surprise. And this is the more striking because his photographs avoid formal tricks.

Finally, their surprise derives from the quality of their observation: the startled observation of a boy and a dog who have accompanied a highly experienced, intrepid traveller.

With Jean – as with most true artists – the relationship between modesty and pride is a complex one. Or maybe it's simpler than I think. He is modesty itself with those who are modest. And he is as recalcitrant as hell with those who are arrogant. What he and I share nevertheless is a sense of measure. This helps to explain how we have been able to collaborate over many years – and why our collaboration has been productive. Less modest than he, I will say that with the example of three books – *A Fortunate Man*, *The Seventh Man* and *Another Way of Telling* – we have considerably extended the narrative dialogues that are possible between text and images in book form.

We started from what Walker Evans and James Agee achieved in their magnificent *Let Us Now Praise Famous Men*. Exactly where we ended, it is for others to judge, but we covered a lot of ground and have already had a considerable influence on the way other photographers and writers across the world have made books.

So we share a sense of measure. Where mine comes from, I don't know. Perhaps Jean does. Maybe it comes from the process of correcting and correcting again the exaggerations with which I usually begin a project or a vision. It's what comes after a kind of recklessness.

Jean's sense of measure comes from something different. His acquired stance towards life – coming perhaps from his father – is classical. He is clearly aware of the dangers of excess. And yet, inside him, are the dog and the boy. Maybe it's exactly for this contradiction that I love him. In any case, it's from the pain of this contradiction that his stoicism is born, and it's from his stoicism that his sense of measure comes.

We have needed a shared sense of measure in order to create pages which flow. An illustrated book has to advance on two legs, one being the images, the other the text. Both have to adapt to the pace of the other. Both have to refrain from repeating what the other has already done. What so often checks any flow, when images and text are used together, is tautology, the deadening repetition of the same thing being said twice, once with words and once with a

picture. To avoid this and to walk together, in step with the story, a sense of measure is essential. Perhaps this is true – at another level – of all long-standing (long-walking?) friendships.

'The Edge of the World'. I've tried to suggest why such a location, such an *elsewhere*, is intrinsic to Jean's vision and oeuvre. I could put it differently. Jean is always on foreign soil, or Jean is always the stranger. Yet, like all nomads, he knows how the guest behaves and how the host receives. And the paradox is that it's there, on The Edge of the World, that he is at home, as both host and guest. And it is there that I had the privilege and luck of being offered his friendship.

At the Edge of the World

Introduction

'The Edge of the World' – the edges of the world – referred to in the title of this book require explanation. I suggest the following:

Three years ago, following intensive medical examinations, my doctor informed me that I was faced with two options. The first was to let nature take its course, with a possibility of remission but a very real risk of the disease spreading and becoming an almost generalized cancer. The other option was to eradicate the tumour, to go ahead and cut the brute out. This would entail certain damaging side-effects, difficult to avoid, and they would tend to diminish the quality of my life. Temperamentally, I prefer to trust to nature, but I found the idea of an abrupt end in extremely disagreeable circumstances to be intolerable; I felt that I had too much unfinished business. I am not a poker-player, so I chose the less risky option and ended up in a hillside clinic overlooking a rural landscape – the curve of the River Arve (a tributary of the Rhône): a place known as 'The Edge of the World' and familiar to every Genevan. The operation had gone well, the surgeon and his assistant having had long experience of surgery of this kind, and my physical state was very satisfactory. But for the first few days, I was a bit groggy and hardly left my room. Then my joie de vivre returned, and with it claustrophobia, so with the aid of a stick I climbed the flights of stairs to the cafeteria on the clinic's top floor, an idyllic place with a vast panoramic view. This was the famous Edge of the World which I had known since my adolescence, but which had mainly been synonymous with sporting events and walks along the Arve. Now, installed in an armchair in the cafeteria, I drank in the huge scene, feeling like both a voyeur and someone almost mystically absorbed. It was the beginning of December, and there were relatively few people about, mainly dog-owners. I watched various encounters from my observatory, but without appreciating the subtle flavour of each one; I detected antagonisms and even witnessed violent confrontations

(between dogs). But what particularly intrigued me was what went on out of sight, behind the trees, close to the river. That was where mystery lay; I could feel it. Subtle plays of light, unidentified sounds, delightful chance encounters: all of these escaped me. Even binoculars – the equivalent of the telephoto lens on my absent camera – would have been useless. As a poet, I could have used my imagination, let my mind wander, hovered in a dream world. As a writer, schemes for a novel would have come into my mind, and if I had been cut out to be a playwright or a film-maker, the various components of this animated scene would quickly have roused the wish to create a set for them.

As a photographer, I could see only one solution: to leave my watchtower as quickly as possible and go down to the actual spot to smell the smells, exchange glances with people and put up with inevitable comments on the sleek elegance of 'my dog', a Weimaraner. For the dog, Yago, would be bound to play a role even before my photographic equipment did. But I still had a long way to go before I could make such excursions on foot, an exercise heartily recommended by my doctors.

Excursions on the terrain at the Edge of the World gradually became a reality; I regained partial use of my legs, and then one day I couldn't stop myself: a sky out of a Vlaminck painting with those fine, sensual greys literally forced me to take my photographic gear with me on my daily walk. At first, I concentrated on the rocks jutting above the surface of the Arve, the eloquent old tree-trunks, the silent tracks on the path.

I gradually introduced living beings into my pictures: a ghostly, furtive dog slipping away into the undergrowth, the silhouette of a woman outlined against the horizon, rooks consorting in a tree. Darkroom work – otherwise known as the developing of film (black-and-white) and enlarging of material selected from contact sheets – alternated with taking photographs on site. I soon had a file full of prints. Then came the inevitable question: what to do with all these pictures?

Naturally enough, the solution to the materialization of my project, namely the publication of my photographs, involved a broadening of my theme, a sense of distance in relation to this place in Geneva known as 'The Edge of the World'. Hadn't I often felt, in the course of

my travels, this sense of being 'at the edge of the world'? Not necessarily in any geographical sense – that is, facing the void at the place where all roads come to an end. To reach the edge of the world is not necessarily to confront nothingness; it can also involve a sense of achievement. It is certainly the end of a certain world, the world from which one comes, the one to which one belongs and upon which one momentarily turns one's back. In brief, I invited myself to take a journey into the immediate past, with 'edge-of-the-world' stops along the way.

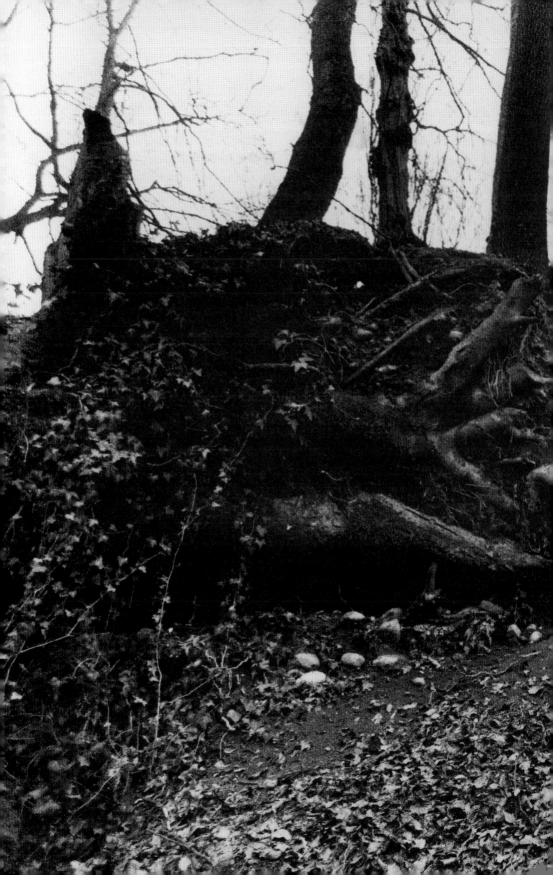

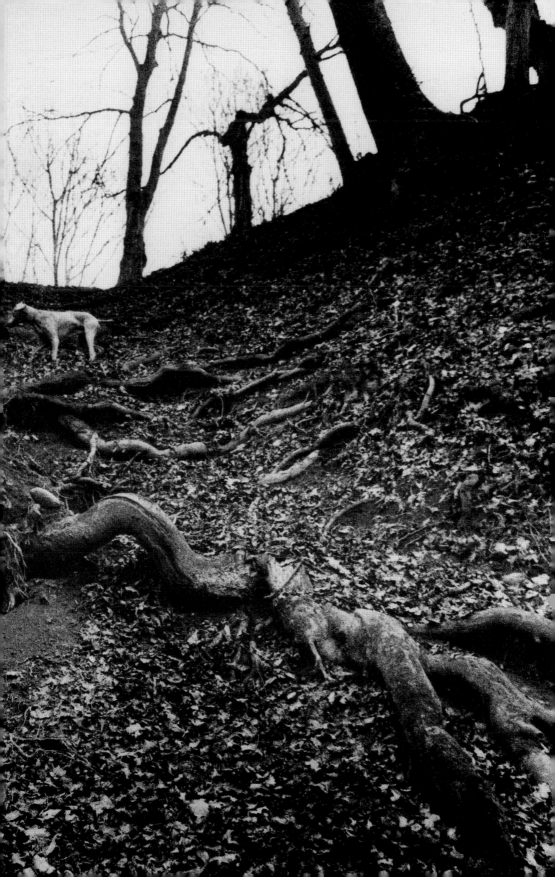

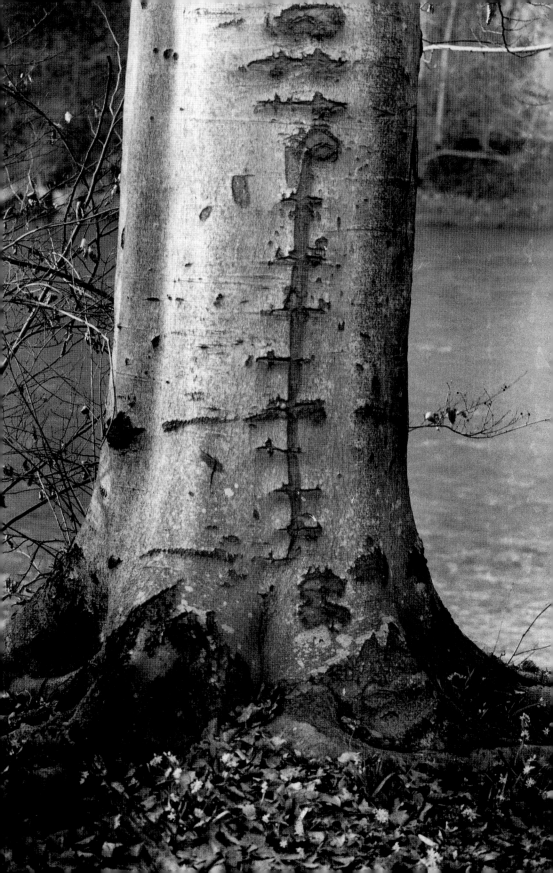

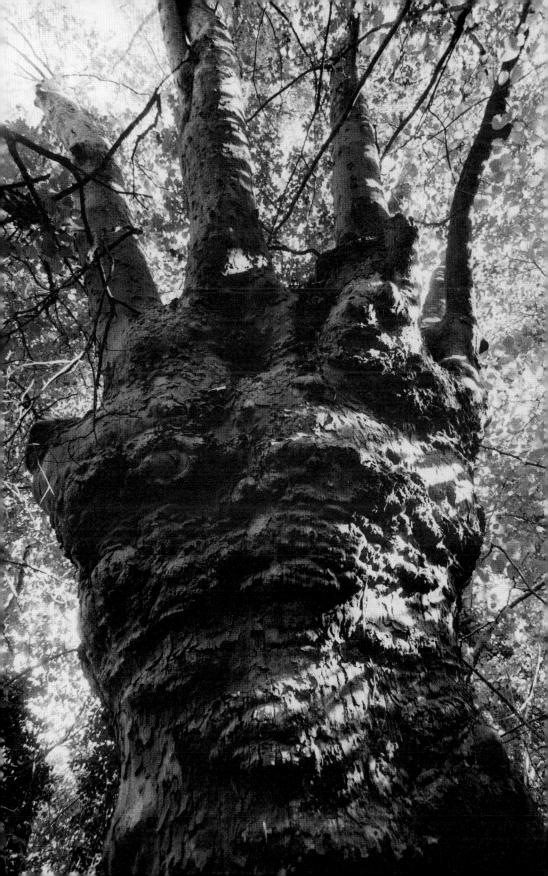

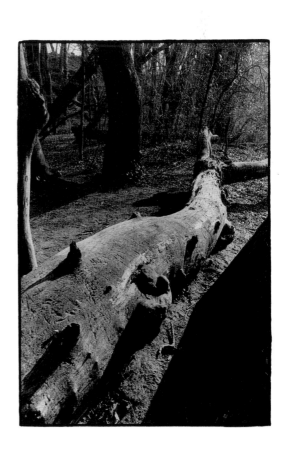

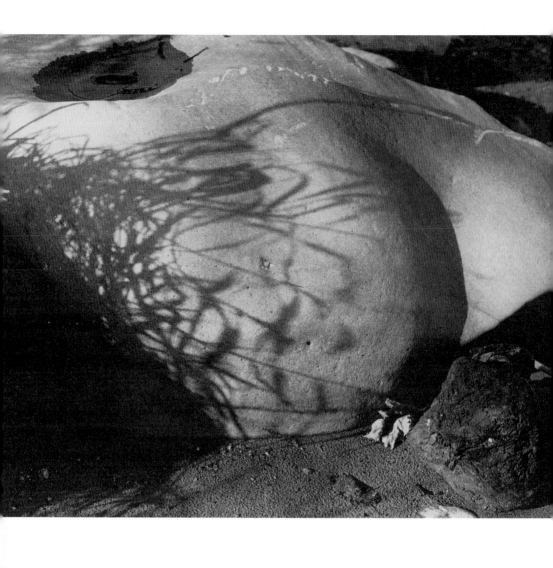

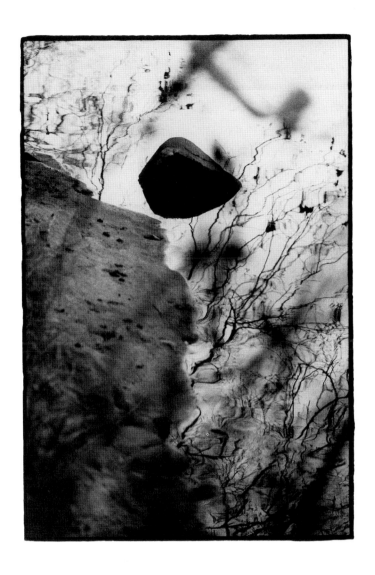

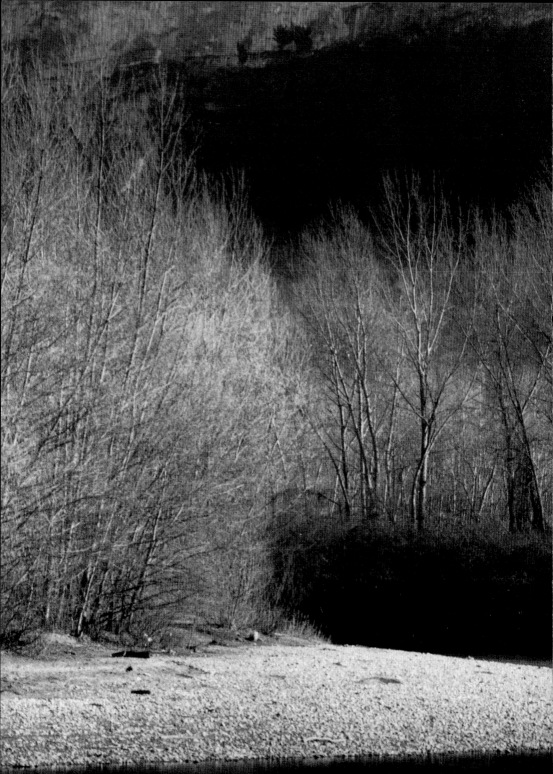

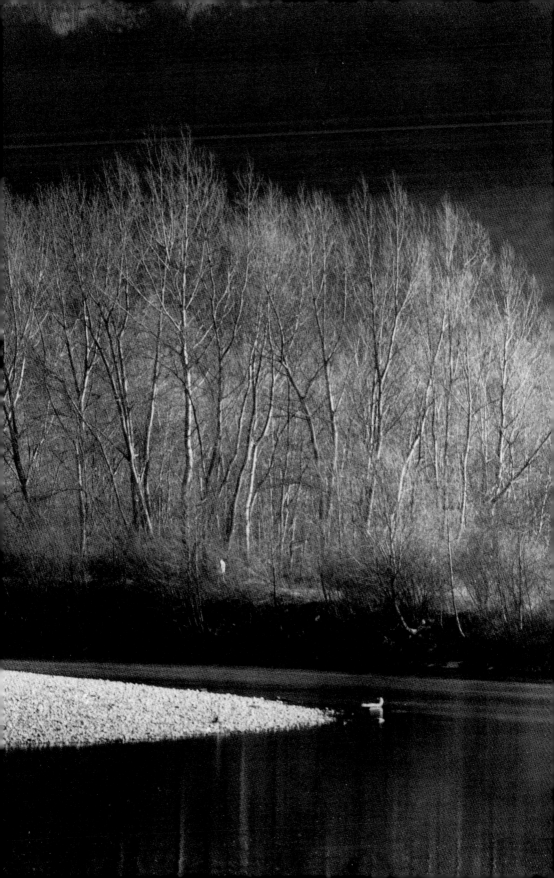

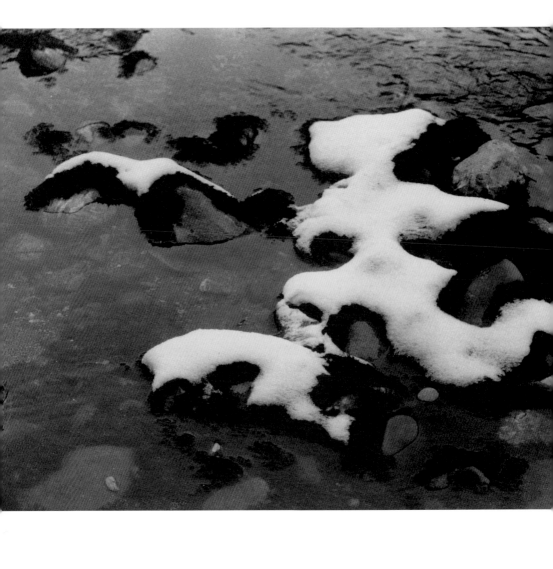

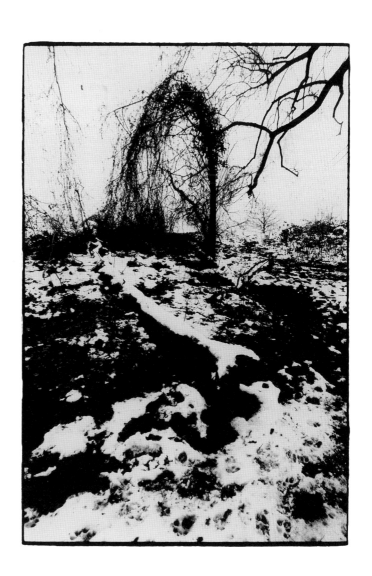

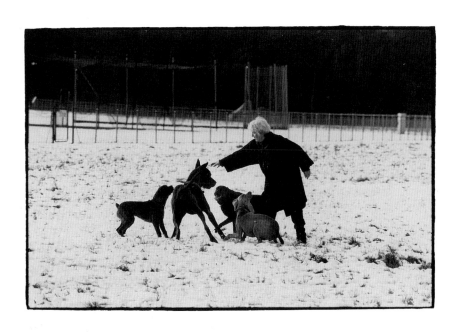

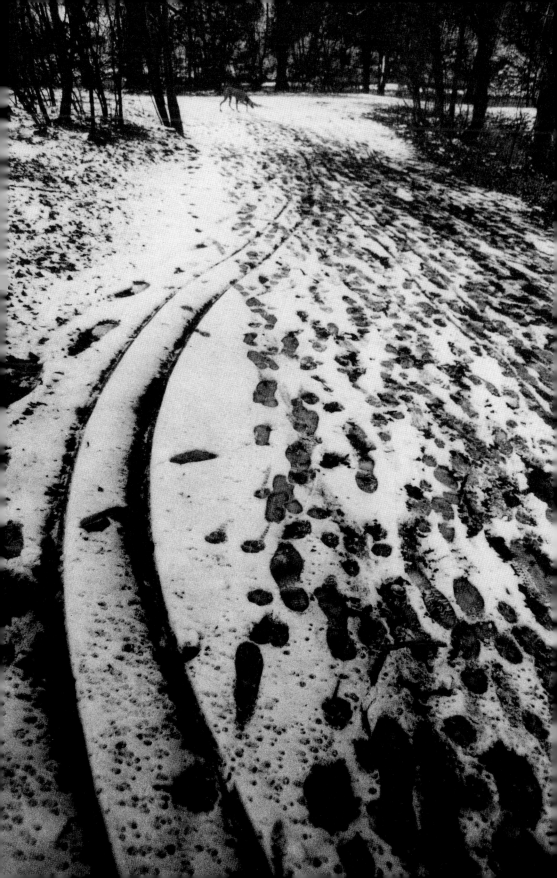

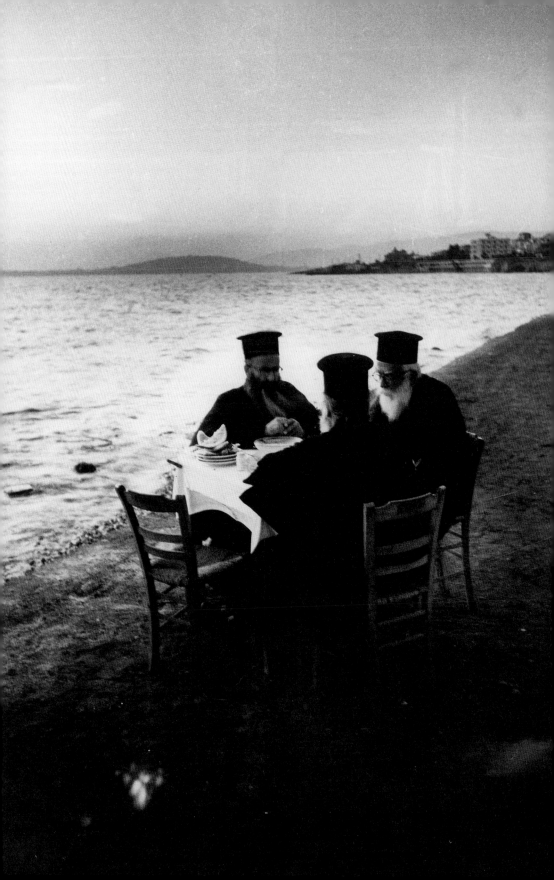

Piraeus, Athens, Greece, 1956

I have no difficulty dating this photograph: it was taken exactly a week after the binding 'I do' was pronounced in the little Veyrier chapel in Geneva. The marriage itself is lost in the fog of memory; I found it hard to realize that the married man was myself, that I had just turned an essential page in my life and that from now on everything would be shared by the two of us. And that this woman whom I loved would be with me more or less permanently. Beginning with the honeymoon journey to Greece that was to start at dawn the next day.

We were at the end of the first week of our stay in Athens. It was nightfall, on a beach in Piraeus. We had spent the day at the Parthenon, amid tourists, drunk with the sunshine and the remains of a prestigious past, duly listed in guides in every language.

Stone shaped by human hands and the work of time exerts an ongoing fascination for me, and I never get tired of trying to find ways to photograph this obsession. Simone, my wife, has a more subdued love of stone. Before long she was searching for a place to shelter from the sun and from parties of tourists and study a Greek–French dictionary and a guide to Crete, the destination of our wedding journey. I found her huddled between two monumental blocks of stone, sitting there quietly out of the way. A dozen or so tourists were fussing around her, Russians I think, trying to find the best angle for a photograph. They were convinced that they had discovered a native who deserved a place in their photograph albums. I let them get on with it. What was the point of correcting an innocent-enough mistake?

After our afternoon at the Parthenon, we went for a long walk on the beach without a bather in sight and with a sumptuous view of the water, the open sea, the sunset. It was then that we stumbled upon a tiny restaurant with an almost predictable but practically irresistible menu: melon, olives, fish, bread and white wine. It was

too early for the regular clientele, but at a table set slightly apart near the water were seated three Orthodox priests, tucking into their meal with obvious relish. Three Orthodox priests, three black toques, three white heads and a fourth unoccupied chair awaiting the un-invited guest. That could not be me; there were two of us. My wife stood some distance away, anxious not to disturb my photographic foray.

'So, young man, you're making the most of a sunset with three men of God in the foreground for good measure?'

I'm making this up, or rather imagining it. What actually happened was that the oldest priest spoke to me in Greek, which I hardly understood, but his knowing smile somehow supported the way I interpreted his words. He offered me a glass of white wine, which I accepted politely before rejoining Simone.

The importance of this image stolen from passing time, the feeling of being at the edge of the world, with that white-hot sun tipping over the horizon, and the fugitive contact of a layperson with men who have chosen to give their lives over to the service of God.

The next day, we were bound for Crete, where we were to find other eloquent stones, other Orthodox priests, as we followed our noses around that island pampered by the Gods.

Wroclaw, Poland, 1958

Before I got to know Poland, I used to wax rather lyrical about the Polish people. As a member of a university mountaineering club in Geneva, I had spent some exhilarating days in the Valais mountains with a delegation of Polish mountaineers the club had invited. They had arrived in Geneva with unexpected presents: neat alcohol, salami, traditional dolls. And their enthusiastic spirit was indestructible. Unfortunately, this Swiss/Polish exchange ended in tragedy. On their last day, an aeroplane excursion had been planned, one of our members being an aviation fanatic. Two Pipers were ordered for the event, and the balletic air display began. Were the pilots over-tired? Was there a misplaced sense of competitiveness? The two planes collided over Chêne-Bourg, an outlying district of Geneva. The death toll was heavy, and there were several Polish victims. I have a muddled memory of subsequent events: the funeral service, the transporting home of the bodies, an overwhelming sense of horror and revulsion. Ever since, whenever I hear Poland or the Polish mentioned, I shudder.

A few years later, I was introduced to Sam by a friend. He was an information officer for a Jewish charity organization. No time was wasted on protocol; he went straight to the point.

'We would like to send you to Poland to take a series of photographs of our various communities.'

'But I'm of German origin, and . . .'

'And you spent two years taking care of Palestinian refugees in the Middle East. I am well aware of all that. But I also know the quality of the work you have done for countless UN projects, and I like it a lot. So, are you up for the job?'

A month later, accompanied by my wife, I travelled north, through Checkpoint Charlie in Berlin, and discovered the 'Communist world', which, at first sight, set itself apart from anything we knew by an impression, along the roads and on the outskirts of

towns, of more poverty than one finds in the so-called free world.

We were looked after in an exemplary manner in Warsaw, with no embarrassing questions asked. I felt, curiously, that I was both a friend and a mercenary. Precise instructions had been sent from Geneva: I was to be treated as a professional and given every possible help in carrying out my work.

After Warsaw and Lodz, I was scheduled to spend a few days in Wroclaw (formerly Breslau), near the Tatra mountains. It was spring, and the Jewish communities were getting ready to celebrate the festival of Pesach. We were invited to the ceremony. I was delighted to have the opportunity to extend the range of material I was covering – schools, kindergartens, training centres.

On the evening of the festival, we were taken into a huge, candle-lit room. Twenty or so guests, including three or four rabbis, were seated around the table. I became the focus of attention. I suddenly realized that I was being stared at in fear. Had I done something wrong? A moment's panic: I was out of place here in front of these men, that much was certain. Then it dawned on me: my appearance could only shock them, with my blue eyes, my fair hair, my build and possibly even a touch of arrogance, the result of momentary dis-comfiture; it all brought back memories they had been branded with, and some of them were possibly survivors of the Holocaust.

The ripple of fear, the icy atmosphere, the expressions of pained reproach, and even the rejection I imagined I read on the faces of some of the guests were all dispelled by our courier.

'Let me introduce Jean Mohr, a Swiss photographer from Geneva, and his wife. They have been sent here by our Geneva bureau, and can I ask you to give them a well-deserved welcome?'

All signs of hostility and fear vanished, room was made for us at the table, and conversations started up.

'Switzerland, such a beautiful country . . .'

And the evening ended very amicably.

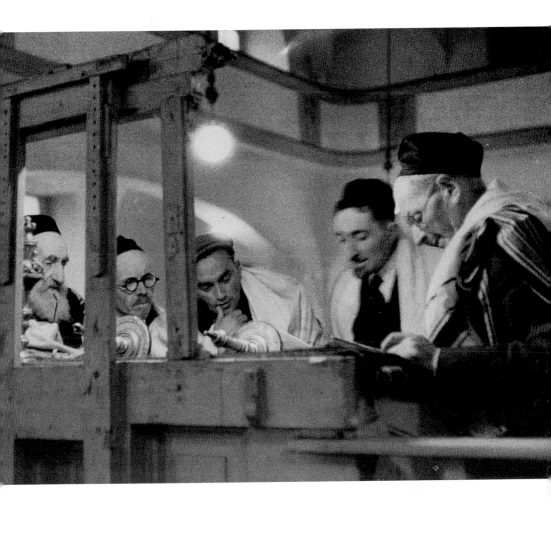

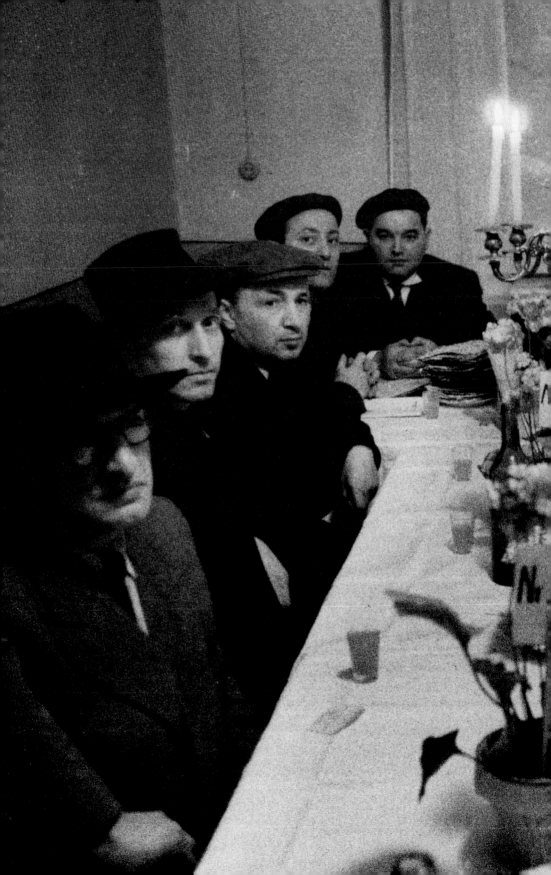

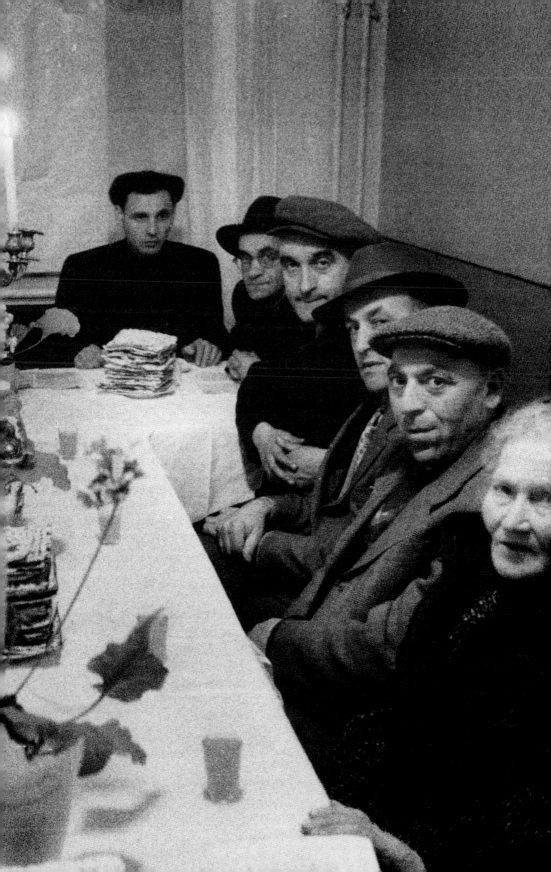

France, 1959: Operation Survival

A high-flown title, very much an operation for the mass media. Or at least it pretended to be. The organizers of this 'operation' had thought up a simulated scientific experiment, somewhere in the French Alps, in the area near the sources of the Arve, at an altitude of about 3,000 metres. The idea was to recreate the survival conditions of ten or so passengers who had escaped from an airliner that had crashed in the mountains.

Volunteers had been selected to act as guinea pigs. A doctor and several high-altitude specialists were to supervise the smooth running of the experiment and intervene in the event of complications.

I got wind of the project from the newspapers. As an enthusiastic mountaineer myself (I had even been an instructor when I was a student), I was immediately hooked. At the time, I was working as a freelance for a Geneva daily paper, *La Tribune de Genève*, as a photographer and occasional journalist. I proposed the subject to them.

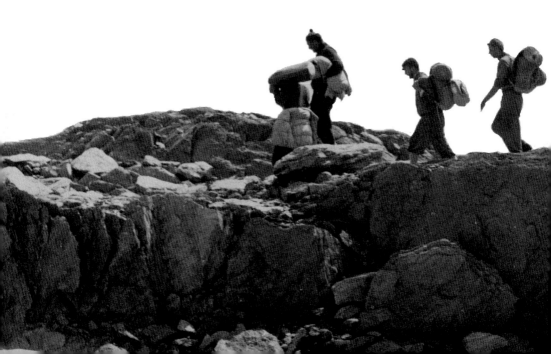

'Agreed. It would be good to give some space to our French neighbours. But be sure to check that this operation is serious – we have our doubts.'

So I set off full of confidence, on my own and with a minimum of information, enthused at the idea of taking part with my camera in an experiment of this importance. To combine my work with my private passion seemed a terrific idea.

To find the location of Operation Survival, I had to ask villagers who lived in the area. I had the right equipment for moderate mountain conditions, even for bad weather. As I made my way towards the spot chosen for the simulated disaster, I came across an increasing number of fellow journalists.

'Hello! Who are you working for?'

'A Swiss paper, *La Tribune de Genève*. What's going on up there? Is there a reception service, a press-relations office?'

'You'll see for yourself. Ciao!'

After a few hundred metres more through the heavy summer snow, someone shouted to me: 'Hey! Who are you? Come over here.' Two dark silhouettes, leaning against a grey rock, stood above me, vaguely threatening. I gave a curt reply, irritated by their interrogatory tone and above all by the situation, half-way up a mountain. It seemed utterly absurd.

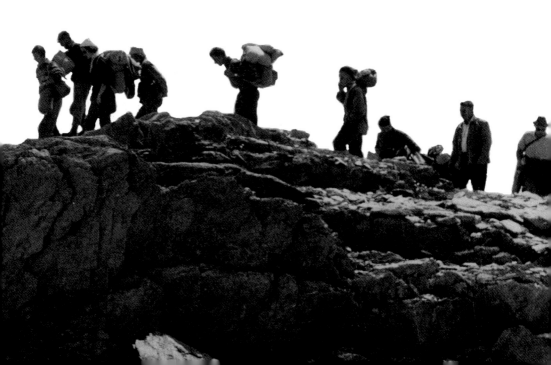

'So, you're freelance, and Swiss into the bargain . . . What are you going to give us as a contribution to our running costs? Your colleagues, *Paris-Match* for instance, have been very generous.'

'Give you? Nothing, nothing at all . . . I'm doing this at my own risk. Who knows whether my photos are going to be published? Anyway, the mountain is a free place as far as I know, so . . .'

I ended to this dialogue of the deaf and went on without a backward glance. On the way, a few rocks tumbled onto my path, no doubt by chance. Or were they a way of warning me off? Taking a roundabout route, I eventually discovered the 'survivors'.

Their ordeal had been going on for two days, and they were enduring it quite well. I felt welcome enough and not too out of place with my equipment. A few hours with them was enough to convince me that the scientific rigour of the experiment was not the strictest, particularly in relation to food and drink, but this in no way discredited the value of the medical and psychological observations being made, notably in the case of a cardiac alert for one of the participants with nothing artificial about it, as well as some severe cases of conjunctivitis.

After two days, I had collected enough photos and material to write an atmospheric description, with one or two reservations about the finer points of this 'survival' operation. So I left the mountain with mixed feelings about the experiment's value (in reality it was pre-experimental, a sort of dress rehearsal). But my head was crammed full of Alpine landscapes very much to my taste: unpretentious, in no way dramatic, apparently tame mid-mountain scenery halfway between pasture-land and high altitudes. An area secretly fraught with the permanent threat of changeable weather, which is what really makes it imposing and dramatic. And those town-dwellers up there involved in a pretend catastrophe, unaware of the real danger hidden in the mountain world! The summer months are a fallow period for the media, and there is a clear need for them to come up with subjects that will catch the interest of their holiday readers. That much is obvious. But how deeply should a journalist get involved in this somewhat bogus game?

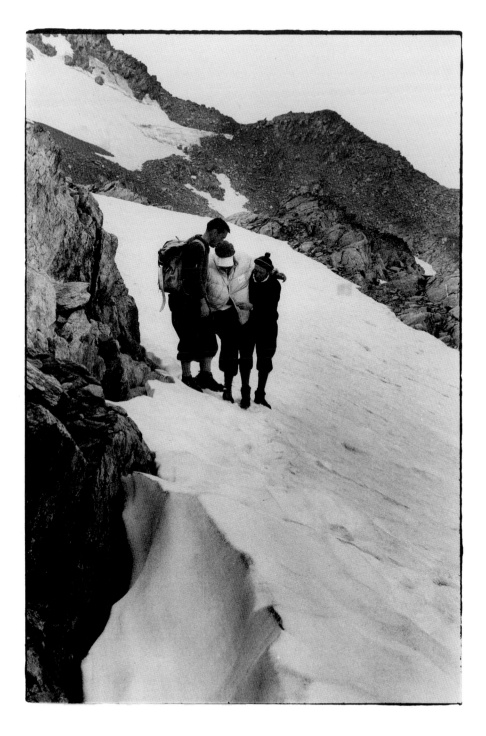

Inari, Lapland, 1960

'So, not much goes on in Inari on Saturday evenings?'

I asked this question without thinking, without much conviction, almost hoping for a negative reply. My legs were heavy from several kilometres of walking through undergrowth and marshland, and this meant that I would get a good night's sleep. Looking at me rather sharply, the hotel manageress told me that in this Garden of Eden there was no need for a cinema, a dance-hall or even a bar. Travellers to this remote Lapland village come to enjoy the quiet, the views into endless distances, maybe even the wriggling trout, but they certainly do not come for social reasons. Nor had I, but I was curious to see how the young people of this barren part of the world found relief from their solitude once a week.

A middle-aged woman, clearly a city-dweller though dressed like a Laplander, came up to us, having overheard our conversation. A resident of Helsinki, she had a keen interest in everything to do with Lapland (rather like Swiss people who have a passion for the Valais or Les Grisons). This meant that she was in touch with everything that went on in the region.

Through her I learned that the young people in the area met up every Saturday night, almost in secret, in an old wooden shack deep in the forest about three kilometres from the village.

'You need to take the main road (in reality, a track of trodden earth) that goes towards the Norwegian border,' she said, 'turn left once you get past the little bridge and follow the path through the birch trees and pines . . .'

It was a sharp night; the sky was crammed with stars and animated by strange milky glimmers. The landscape, seen in daylight at that time of year (early autumn), is almost too rich in colour – an orgy of brightness which lasts for a week at most; at night, it assumes its true proportions, its rightful face, at once austere and poetic.

Towards nine o'clock, I found the location of this nocturnal meeting-

place. No light, locked doors, total silence. Had I got the place, the day, the time wrong? I waited half an hour on the wooden staircase in the company of a small dog much given to licking. She had come there out of the blue, trusting and patient.

Then the party-goers arrived, alone or in small groups, silent, unhurried, looming out of the darkness. They hardly seemed surprised to find a shivering stranger, his eyes bright with curiosity. Some had come on bicycles, one in an old car, the rest on foot.

Inside, everything took a long time to organize: setting up the gramophone, organizing a primitive bar (drinks and biscuits). One of the young men took his place at the entrance to sell dance tickets. For almost an hour, the young men and women hardly exchanged a word with each other, as if they were waiting for some mysterious permission to be given, some signal to go ahead.

Then, gradually, the atmosphere unfroze; the same records went on being played, couples started to dance in earnest, and there was even the occasional splash of laughter. Further arrivals included several older men, some of whom had obviously had too much to drink. They had come merely as bystanders with a need to feel a bit of real human warmth and to let themselves be lulled by this blend of raucous music and whispered conversation.

By the time I decided to leave, the party was well under way. I plunged into that dark night at the edge of the world and discovered when I got back to the village that its silence was scarcely disturbed by the distant rumble of the dance in the Lapp countryside.

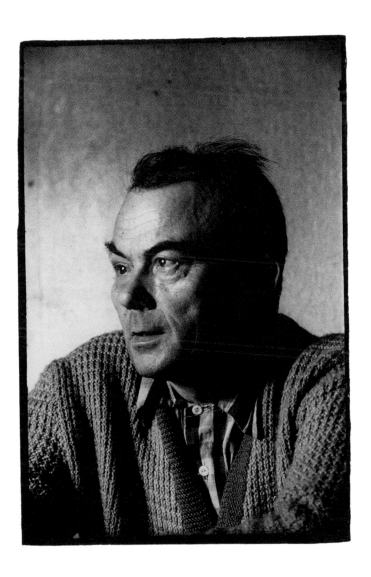

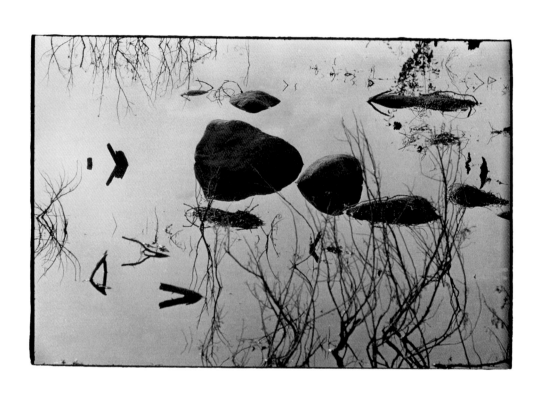

Romania, 1961: Malaria

In the 1960s, Ceausescu's Romania was reputed to be one of the most impenetrable countries in Eastern Europe, and Western journalists were not exactly welcome there. It is true that there were some signs of the country opening up to Western Europe, notably the seaside resort of Mamaia, whose tower-blocks were set directly on the beach with a view to attracting foreign tourists at unbeatable prices. But this was an instance of mass tourism, of a suitably contained clientele parked in newly opened hotels with two- or three-star ratings at the very most. It meant that local authorities did not have to worry about the misplaced curiosity of over-adventurous or nosy visitors.

The latter was the category to which I belonged due to profession. But, as it happened, I had been sent to Romania by the WHO to report on the latest count of malaria cases. 'Special Correspondent for the World Health Organization' was a rather snooty-sounding title, but at least it guaranteed a welcome and decent treatment from the Ministry of Health.

On the strength of this official status, I asked the Romanian Embassy in Switzerland for a visa for my wife. I was told that one would be available, but that she would have to stay in a different hotel from my own, a hotel for tourists . . . This was a first indication of distrust, possibly explained by overly efficient officialdom. Needless to say, we rejected such a ridiculous suggestion. So I left on my own for Romania, the out-and-out stronghold of Soviet-style Communism.

Once I got there, everything went pretty well according to plan. A great deal of time spent in offices, never-ending discussions, an overdose of strong coffee and, to all intents and purposes, a perfectly reasonable willingness to co-operate. With one major exception: I was scheduled to visit the delta of the Danube, a choice area for malaria . . . and for pelicans.

'We're sorry, but it's a military zone of great strategic importance. There is no possibility of your being allowed to visit it.'

'Couldn't I ask headquarters in Geneva to arrange for a special pass?'

'Maybe . . . but it would take seven to ten days.'

This was out of the question; I was unsure whether I would get the pass, and my time was limited. The relationship I had formed with the medical staff who had been instructed to take charge of my visit had been friendly and unburdened by administrative concerns. When they learned about this second manifestation of distrust towards me, they discussed the matter among themselves, and one of them made a suggestion.

'The way you've been treated is unfortunate and quite ridiculous. You know what bureaucracy is like . . . What we suggest is that you leave your luggage in Mamaia, pay for a week in the hotel, and we'll come and fetch you in a jeep without drawing attention to ourselves. You'll be able to do what you have to do as part of a medical team making their rounds in the delta. No-one will interfere. You can stop worrying.'

I went along with their suggestion. In fact, they were taking more risks than I was, but no doubt they were better acquainted with how to play the system than I, and they were also protected by their profession. We followed their plan, and the trip by jeep from village to village, often along muddy paths and ending in a fishing boat, was a total success.

Travelling with doctors in remote places means that you are always certain of a warm welcome. Even malaria experts can give good medical advice and distribute medicine for problems outside their own particular specialities. The doctors with whom I travelled had the added advantage of being open men, good companions, funny even, and delighted by this improvised escape into truancy.

All my work was part of a world-wide programme to eradicate malaria. There was much talk at the time of eradicating major diseases, and there was a slightly forced optimism about the entire undertaking. Subsequently, it was discovered that the malaria-carrying mosquito was able to thwart the traps set for it; malaria returned in a different form, so nothing had been solved. But that is another story.

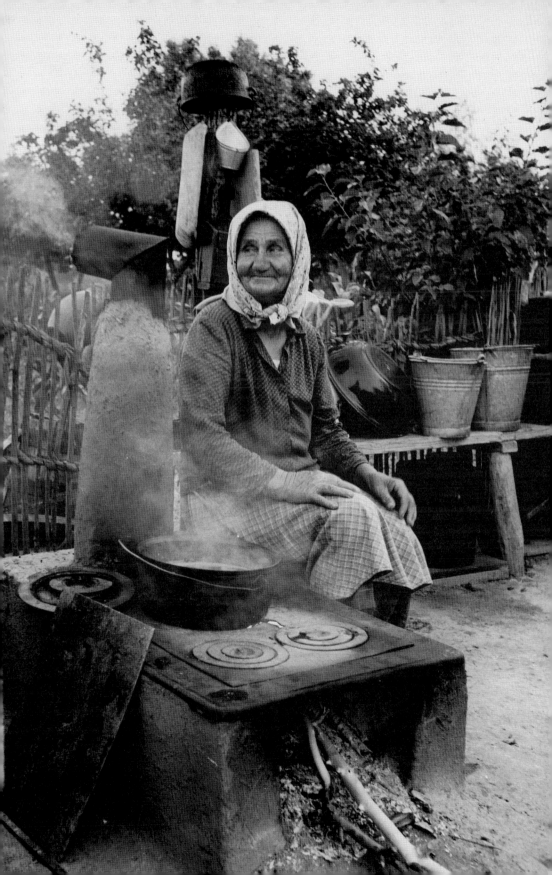

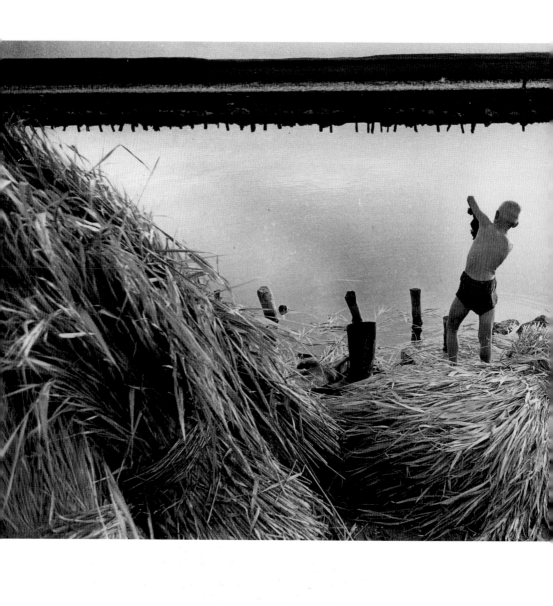

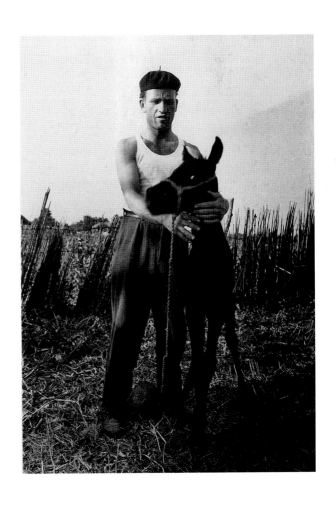

North Korea, 1962

July, Chantepoulet in Geneva. Two people brazenly cross the road without using the pedestrian crossing, two men who are about to meet in the middle, apparent strangers. As they draw level, one of them calls out: 'Jean! I don't believe it!' A slight hesitation on my part (I am the other man), and then: 'Good lord, it's Roland! What are you up to these days?'

We go and find a table on a café terrace and immediately start telling each other about our lives. How many years has it been? Five. We first met each other at the University Arts Society, principally devoted to chamber music at the time.

I gave him a jumbled account of what I had been doing during the previous few years: my work as International Red Cross delegate in the Middle East, my marriage, my photographic activities. He told me in turn that he had followed the political convictions he had adopted as a student, opened a left-wing bookshop and specialized in cultural exchanges with countries of the Eastern Bloc and Communist Asia.

He suddenly broke off in the middle of his account, stared at me intently and asked: 'Are you free in the next few weeks? For a trip to Korea, all expenses paid. You'll have to make up your mind quickly . . .'

'Korea? Which part . . .?'

A hint of reproach flickered across his otherwise kindly face.

'Come off it, you know where my sympathies lie! I arranged for a dance company to come from Pyonyang last year. They were delighted by the way they were welcomed in Europe, and they want to show their gratitude. So they've invited several eminent Swiss intellectuals and artists to go to North Korea. I've had no luck. People are frightened! Even Frisch and Dürrenmatt have declined. So why don't you come as *The* Great Swiss Photographer? There'd be a small exhibition thrown in.'

It did not take me long to make up my mind, despite the fact that I had little sympathy with the regime in this distant country. The question of visas was quickly sorted out, and we met up again on an aeroplane at the end of July, travelling light and with a sense of real excitement. Zurich, Prague, Moscow, a stop in Siberia and then Pyongyang. Our welcome was both formal and friendly. We immediately had an interpreter and a 'guardian angel' assigned to us, both of them extremely helpful young men. As time went by, we all became good friends despite the reports they had to supply to their superiors at the end of each day. The Koreans described us as 'long-nosed', and many of them were alarmed by our body hair. Our schedule, followed down to the last detail, took us all over the country, even as far as the famous Diamond Mountain near the South Korean border.

We returned to the capital exhausted and overwhelmed with impressions. That evening, our 'guardian angel' knocked on the door of our hotel room.

'I'm very sorry, but I'm going to have to ask you to hand over all your reels of film. They will be developed during the night and given back to you just before you fly home.'

I have to admit that I had rather expected this to happen. My interlocutor seemed far more upset than I was. On the plane, I was able to assess the extent of the censorship at my leisure: all the shots of barefoot children, mothers carrying their babies on their backs, traditional craftsmen at work – in brief, everything that could be described as 'retrograde' – had been removed. And since the films had been developed in an army laboratory, the quality left a lot to be desired. At all events, my material was not very widely published. No doubt, it was too tame for Western consumption.

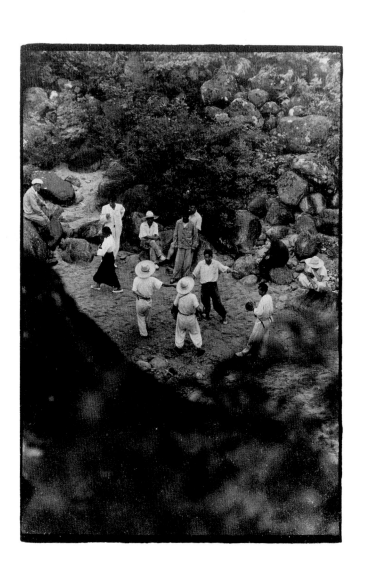

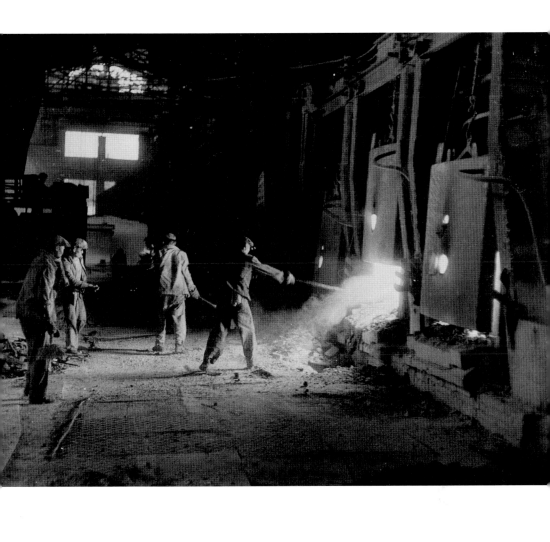

An Aran Island, 1965

There are place names that have a magical sound to them, like Samarkand, Timbuktu, St Petersburg. We have all got our private stock of them, collected from books, films and legends. Or based on accounts given by friends who are particularly good at describing their travels.

For me, the Isle of Aran, off the west coast of Ireland, never failed to conjure up O'Flaherty's wonderful documentary film *The Aran Islander*, for a long time one of the most treasured features of film-club programmes. In the course of a solitary journey across Ireland, I was eventually able to treat myself, on the west coast, to a pleasurable diversion out onto the open sea, and to land in the Aran Islands.

Some notes from my travel journal:

Saturday 22nd. In spite of a mixture of showers and bright spells, today has possibly been the best I've spent so far on this Irish visit. Yet it started badly: the boat trip from Galway to Irishmore (the largest of the Aran Islands) lasts three hours, the sea was rough, and although I took refuge on deck, I started to feel seasick after two hours studying the sea. Perhaps I should have scrutinized the fighting seagulls and crests of waves less intensely.

Arriving on Irishmore, the big island, was disappointing. A few cars, horse-drawn carts, farmer-fishermen (or fishermen-farmers?), a handful of summer visitors. And houses very similar to those on the coast just opposite. An old man in a cap, with protruding ears, came up and offered his services, proposing a rapid tour of the island in his horse and cart. Why not play the tourist? I looked just like one, it seemed to me.

An hour and a half spent being shaken about in a vertical position are preferable to that insidious rocking motion on deck a while back: I feel myself come to life. Nothing spectacular meets the eye: walls twice as high as those on the Irish coast, women

turning away and hiding their faces at the sight of a camera, O'Flaherty's house in the distance. My guide remarked: 'Flaherty didn't really come from Ireland, you know. He adopted the name so that he could get on with his work in peace.'

In the far distance, megalithic ruins, in particular the famous fort of Don Aonghusa. It would all take days of slow and patient work, of enthusiasm. What interests me today is the third island, the smallest, the (almost) virgin one: Inisheer.

We arrive back in the port just in time to get back on the boat. The sea is much calmer; at least the boat is pitching less, perhaps because of the change of course. In the distance, between the two small islands, there are huge waves breaking against the cliff. We finally land on Inisheer. The enchantment begins.

There is the immediate certainty that this is one of those privileged places where nothing is adulterated, where people's responses, whether friendly or hostile, are spontaneous. There is no port, just a vast beach of fine sand. The whole population, men and boys at the front, women and girls behind, is there on the shore. The boat casts anchor about 150 metres from the beach. Five or six small boats came up to our own. Goods for the island were unloaded, and passengers who wanted to get off. Among them, a young farmer in a woollen cap, armed with a stick. He can only be about twenty. His arrival has been eagerly awaited, with hope and anxiety. He will leave again in two hours' time after selecting for sale twenty or so cows and bulls from the island's livestock.

At the moment, farmers are coming from the four corners of the island with their animals, as though to some kind of religious ceremony, or rather some sacrificial rite. They stand apart from each other, pretending not to know one another, in a huge semi-circle on the beach, waiting for the buyer to come and examine their cow or bull, to run his hands over it and estimate its value.

Once business is concluded, the animal is brought to the shore. Half a dozen men tie heavy ropes around it, then push it towards the sea or throw it down onto the beach and drag it into the water. Meanwhile a small boat approaches with four men in it (three rowers and one man whose job it is to get the animal up to the boat). The animal is more or less resistant, but sooner or later it

gives up and finds itself in the sea. It is joined to the fourth boat-man by a rope tied to its horns, and he pulls on the rope until the animal reaches the boat. He then hoists up the cow by its horns, takes its head onto his knees. The crew sets off, rowing furiously, towards the boat we have come on.

On board, there is a crane to hoist the animal up into the air and let it down into the hold. Needless to say, the cattle struggle against all this handling and loose control of their natural functions, liquid and solid, but the decks are immediately and thoroughly washed down.

Boarding cattle in this way might seem brutal and old-fashioned, but there is no cruelty involved, and the only way of doing it differently would no doubt be to use a 'Liberty ship' or to build a port (a costly and not very profitable business). But Inisheer would then no longer be the small, bare island it is, the perfect place for anyone who wants to take a few months' break from things.

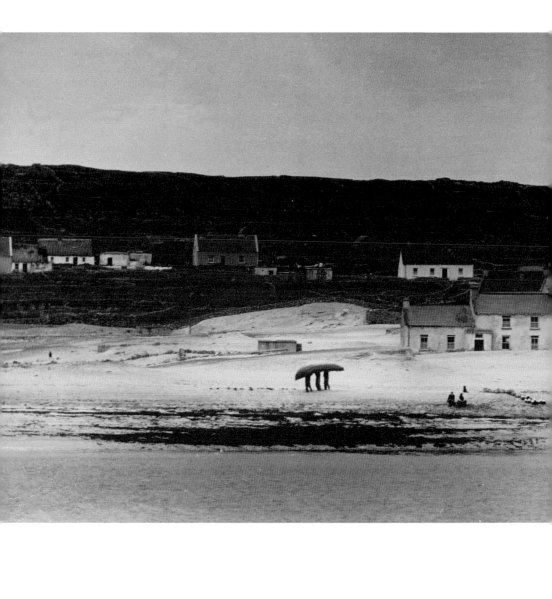

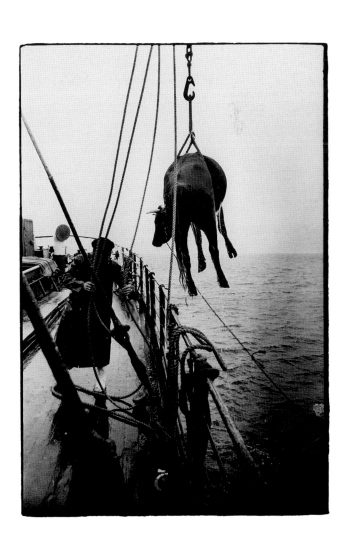

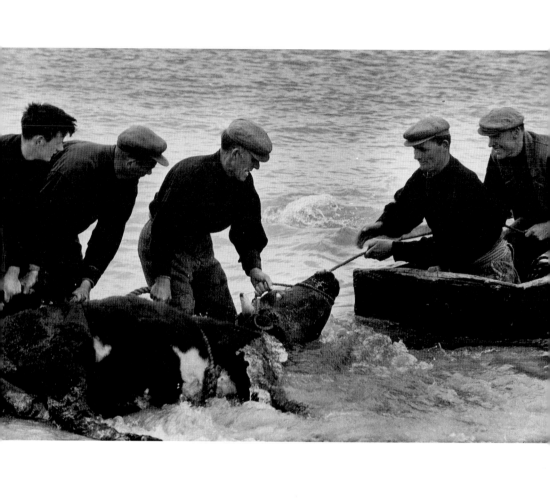

Jersey, 1967

A small island warmed by the Gulf Stream, set between Great Britain and France. But it could not have been more English. It was also famous for several reasons. What particularly drew me there was Gerald Durrell's zoo, well known for its exotic animals and the large number of same that had been born there. This was partly due to the favourable climatic conditions but also to the relationship that had been established between the keepers and the animals. 'Keepers' is hardly the right word. The staff had been hand picked, and they were expected to have a genuine sense of vocation and an exemplary way of handling animals. I had been given this assignment by one of the UN departments, with a briefing to illustrate this 'modern' approach to animals, particularly ones reputed to be dangerous. There was the added bonus of doing an interview with Durrell, the master of the place.

Owing to a misunderstanding, I arrived on the island at the end of spring, when the zoologist-author was away. 'Never mind,' I thought. 'I'll stay here for a good week anyway; that will give me the time to see how things work and to do the photography. I'll come back and do the interview in the summer and possibly collect a few more photographs.' Durrell's assistants had been told to give me all the help they could. I was an intruder, but a VIP one who had to be treated properly. Six or eight pages in a magazine with world-wide distribution was something worth having, and there was no question of treating me like a paparazzo.

My interest was quick to focus on the primates, in other words the apes. Gorillas, orang-utans and chimpanzees are rather like our distant cousins, are they not? To meet their gaze was somewhat disconcerting . . . One morning, I was present when their cages were being cleaned out. Outside the cages, of course, because they had not yet grown accustomed to me: this man with his bag, his weird black apparatus, his prying eyes, what was he doing there exactly; was he

a friend or an enemy? A young woman who was in charge of the orang-utans had been watching me. Sensing my frustration (those irons bars in the foreground!), she asked: 'Would you like to get closer to these primates? With most of them, it isn't really possible in so short a time; it's too dangerous. But this young female here, Ophelia, is very quiet and affectionate. You can take a little walk with her if you like. She knows where to go, there's no danger.'

I was introduced to Ophelia following the proprieties – 'Jean – Ophelia. Ophelia – Jean' – and off we went hand in hand. I realized almost immediately that I was not the leading partner. She was leading me. Her grasp was warm and firm.

To say that I was disconcerted would be an understatement. I felt as though I was on the edge of an abyss, at the edge of the world, the human world that is, and being drawn into the animal world with nothing to guide me.

Ophelia turned and led me back, gently but firmly, to her half-open cage, which had now been seen to. Right at the back in the half-light, I got a glimpse of Ophelia's mate, whose name I have forgotten, and who had been keeping a close eye on our escapade.

'Did everything go smoothly?'

It felt as if a fairly important initiation ordeal was the subject of this question.

'Yes, thank you. I've come through it unscathed. It was very moving.'

I also made contact with the other primates, but more superficially: an exchange of glances, tummy rumblings from both parties and the assurance that there was no harm intended. The week passed very quickly, and I left for Geneva with a fine collection of photographs.

In mid-summer, certain this time of meeting up with Gerald Durrell, I went back to the island. It was a Sunday and very hot, and a large crowd of people were traipsing around from cage to cage. The animals themselves were taking their afternoon naps and showed no interest in the visitors, despite all the cries and antics directed at them to rouse them from their torpor. I reached the cage of the two orang-utans, who were slumped against the tree put there for them to climb on. I was unable to get to the front because of the throng of people. But Ophelia's mate half-opened his eye and recognized me

at once. In one great leap, he hurled himself towards me in an attempt to get me in his grip. People fled screaming. I stayed at a safe distance, just near enough to hear his abuse while avoiding his spitting. I tried in vain to offer my apologies. Ophelia had not stirred, completely indifferent to it all as far as one could tell. It was clearly all to do with some conflict between two men which had not been resolved for lack of adequate communication. I felt sure that with a common language, the misunderstanding could have been cleared up quickly. After all, my intentions had been entirely honourable . . . as far as my interest in Ophelia was concerned, that is. A few hours later, I recounted this mishap to Gerald Durrell, who was in no way surprised by my tale, restricting himself to a wry smile.

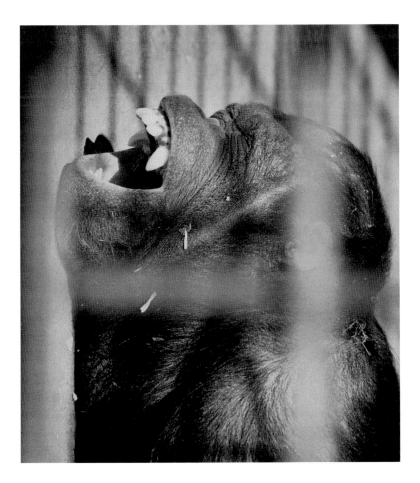

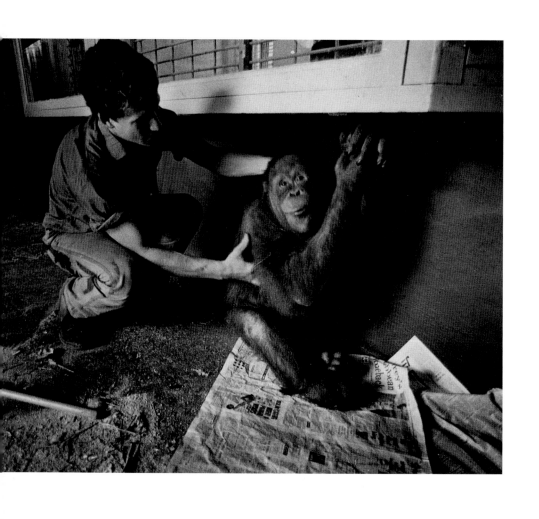

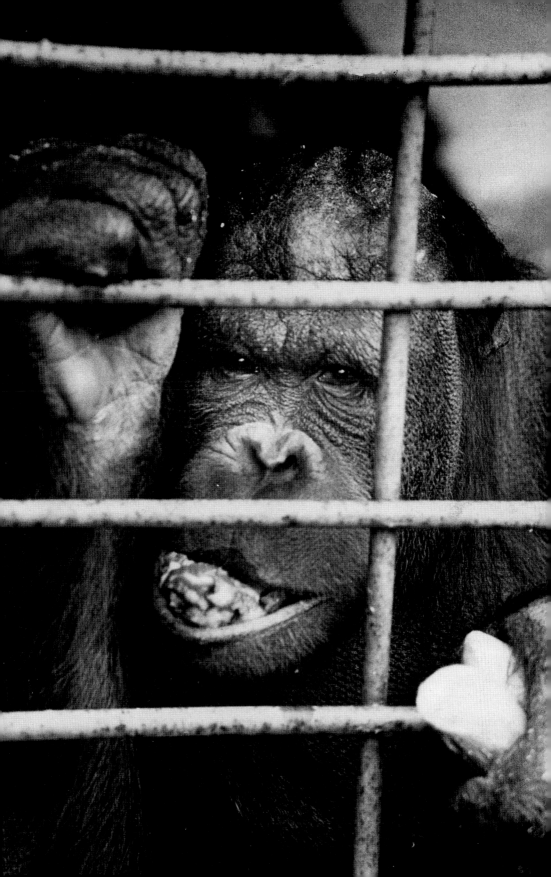

Greece, 1967: Pausanias

What had been proposed to me was very tempting: to provide black-and-white photographic illustrations for a guide (the first of its kind, no doubt, drawn up in the second century AD) by a Roman general, Pausanias, who had been posted to Greece. There were several translations – one very good one existed in French – but no illustrated ones. The man who made this proposal to me was a dashing Jesuit from Cambridge who dabbled in the priesthood and dressed like a refined hippie in jeans and a pink shirt. He pointed out the difficulties. Pausanias's guide described some temples and locations that had virtually disappeared; other sites were preserved but situated far from decent roads. Commercially produced contemporary tourist guides were unreliable. In other words, suitable transport capable of fording a half-dried-up river was essential. A jeep, for instance. (I had something better to hand: a Citroen ID with adjustable wheel positions.) Some knowledge of Greek was desirable; tourists did not venture into the areas in question.

My liking for the country grew as the days went by, despite certain physical difficulties; I am a reasonably good driver but a very poor mechanic. I was greeted everywhere like a welcome visitor, not as a tourist. Meals were often very frugal:

'We have tomatoes and peas; what would you like?'

'Both.'

'Sorry, you have to choose between them.'

One day, in a small village far off the beaten track, I came across a funeral. I hesitated a moment: should I take my camera out? The officiating priest noted my scruples and put me at ease with the broadest of smiles, the signal to go ahead. The ceremony in the church, which took place to lulling chants amid the smell of incense, was followed by a slow procession through the village, the dead woman lying in her coffin with her face uncovered. What serenity! Death

had come at the appointed moment to give a smooth deliverance to a woman who had lived out her time.

My presence as an unannounced visitor who had been welcomed into the ceremony seemed part of a plan whose meaning escaped me. I felt as if it had been meant to be. I even found myself thinking: 'If only I could die like this, when the time comes, without creating fear and distress, in perfect harmony with those around me, still present, lying there with a vague smile on my face, but at the same time already passed into the beyond, lightly, gently.'

But a few days later, I came down to earth abruptly. It was late afternoon; the day had been fruitful; I was driving towards Olympia, when I was stopped at a cross-roads by a military patrol. Three men in combat dress shouted at me vociferously, menacingly.

'What are you doing on the road at this time of day? It's illegal and it's dangerous . . . There's a curfew on! Go to the next hotel, four kilometres down the road, and keep out of the way.'

Once we were in a safe place, I found out what was going on: the Colonels' coup d'état, the whole country at a standstill. The next day I started back to Switzerland after a month and a half away. The Pausanias guide and my photographs never saw the light of day – to publish them would have been to support a regime with very little democracy about it.

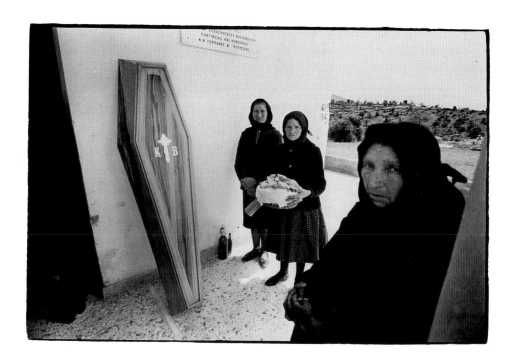

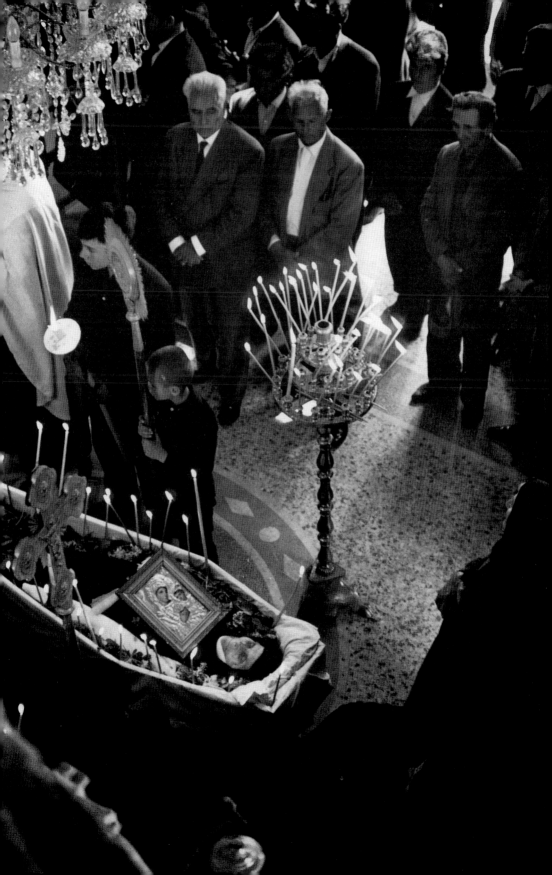

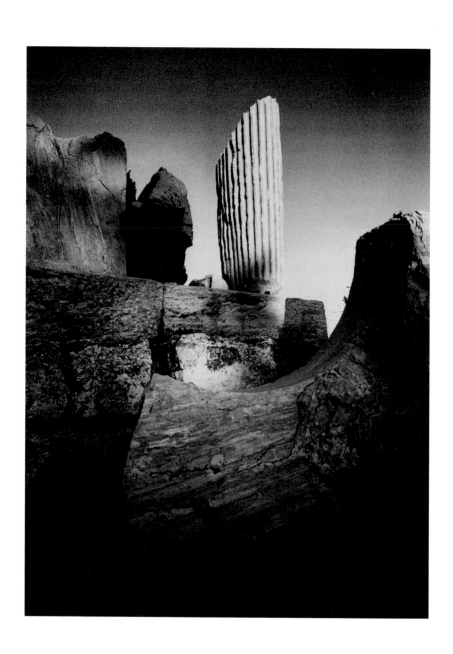

Bangui, Central African Republic, 1970

The autumn had been a real African marathon. There were two of us, a Swedish journalist and myself, and we had been invited by the World Health Organization to report on certain aspects of the continent's medical situation.

Unlike in Asia, there was a scarcity of family-planning schemes. In certain places, it had even been necessary to find new solutions to the problem of sterility. The topics we had to report on were malaria, urban hygiene and the training of qualified medical staff capable of acting as 'barefoot doctors' in the bush.

We had been given a warm welcome everywhere: visiting European journalists are considered a godsend. In fact, Western media gave little coverage to the situations in various African countries: Gabon, Botswana, the Central African Republic. Who was interested in these obscure, recently decolonized states? It is true that Biafra had hit the headlines for a few weeks (television did not yet have the prominence it has now), but this was a striking exception to the rule. We finally landed in Bangui, the last stop on our African mission. We were to visit a de-pollution and drainage scheme in the immediate vicinity of the capital with three main topics to investigate: manual labour, picks and shovels, work sites; hygienic conditions at the site; the professional training of those running the scheme. The man in charge was a Swiss engineer, an expert on water pollution, who immediately made himself available to us.

Ten years earlier, the River Oubangi had risen massively, and the streets of the capital had been flooded. It was then that the idea of a de-pollution project had arisen. The drainage of rainwater was the most urgent requirement – hence the need to build canals. The principal aims of the scheme were to make people realize what was needed and to provide the possibility to maintain existing installations.

With our mentor, we drew up a broad programme of things to see, arranging to meet the next day. I was certain that I would find good

photographic subjects; I had in fact already glimpsed a few of the workmen's faces on a rapid tour of the site, faces like ebony masks.

We returned to our hotel near the river for our evening meal. We were both in very good spirits; our journey was nearly completed, and things augured well for the final part of it.

There were few foreigners, or at least few non-Africans, in the communal dining-room. The radio was playing the sort of music you hear anywhere; then the news came on. The first item was a warning in perfect French: 'Will the two journalists sent by the United Nations please not leave their hotel until further notice. They are not to leave the building. They will receive instructions in due course.' Everyone in the room understood every word and realized who we were, although no-one stared at us or made any comments.

Needless to say, we were worried. Should we react violently, in the time-honoured White tradition? Or should we discuss things, make positive suggestions to charm people over to our side before asking for an explanation of this ridiculous veto? And to whom were we to speak? Luckily, our Genevan expert arrived at the hotel with a sheepish, slightly amused look on his face, immediately reassuring us.

'There is no cause for alarm. We are in Africa, and the country's ruler, General Bokassa, is given to this sort of impulsive reaction. This is what has happened. In the course of the Bastille Day celebrations, the French ambassador made certain unfortunate remarks which annoyed the Chief of State, and this has resulted in the deportation of 65 French volunteer workers. They included several agricultural experts who were in charge of a model farm. That's right, the one we were going to visit . . . And it seems that the farm is in a complete mess; most of the cows have died! The place stinks to high heaven, and for several kilometres around. Now Bokassa, who was visiting Taipei, returned home earlier than expected. He asked to be brought up to date on current events, his attention was drawn to our programme, and he reacted violently ('It's out of the question to take foreign journalists to that place'). So he ordered your confinement to the hotel without any explanation. It will all sort itself out in a few days. Meanwhile, I propose that we stick to our programme. But to get you out of town and through the checkpoints, you're going to have to hide in the back of the vehicle. Okay?'

So we did. A day or two later, as expected, the orders imposed

upon the two journalists were lifted; there were even apologies and an invitation to prolong our stay. But we had plane tickets that did not allow us to change our departure dates, so that was the end of our Bokassa experience.

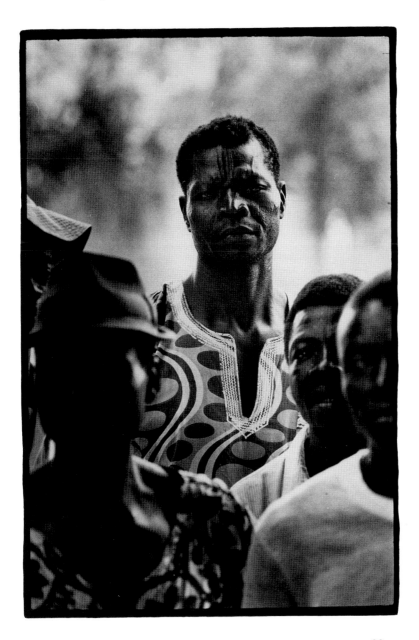

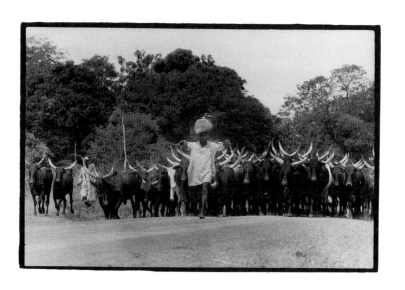

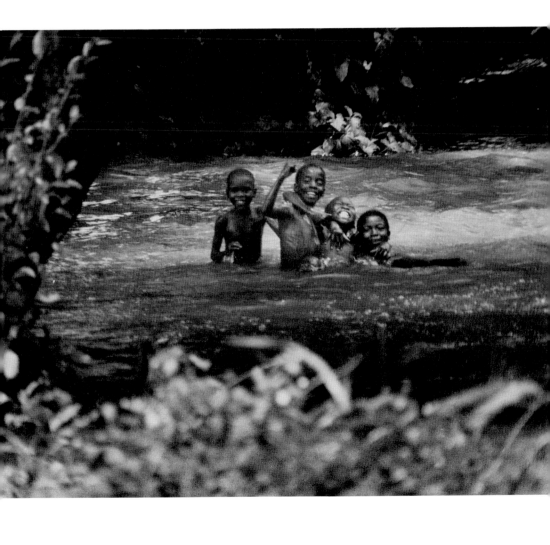

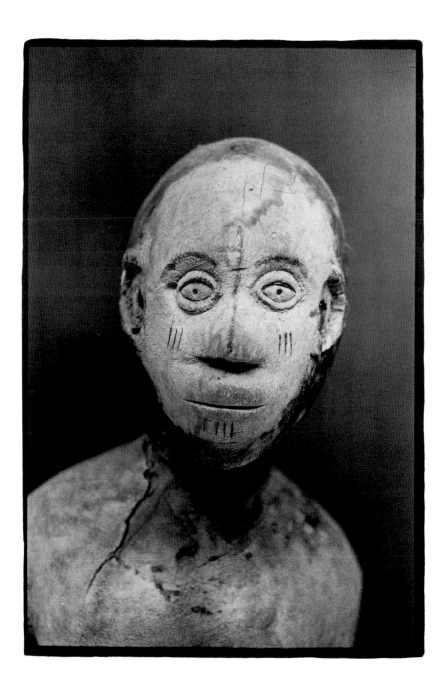

Manila, Philippines, 1971: An asylum

On a tour of South-east Asia, I was scheduled to visit a psychiatric asylum in Manila.

A few years previously, I had had occasion to report in detail on a clinic in Geneva run by a highly thought-of, extremely genial professor. The themes I explored then were the liberalization of the health-care system (which had been almost prison-like up to that point), the ending of taboos, and the blurring of distinctions between the insides and outsides of asylums. The key image in my report was the removal of the iron bars from most of the clinic's windows.

So I arrived in Manila with my head teeming with generous ideas and liberating images of modern psychiatry. I received a friendly welcome from the doctor in charge, who was well acquainted with his Genevan colleague. My meeting with him was drawing to a close and I was ready to get down to work, but one thing worried me.

'All these bars,' I said. 'Don't they run counter to present-day thinking? In Geneva, you know, we . . .'

He gave me a faintly ironic smile.

'My dear friend, these bars are not there to stop our inmates escaping but to prevent people outside from getting in. The food is quite good, you see.'

My thoughtless remark was no doubt put down to insufficient briefing, or to sheer simple-mindedness.

My report went well, in spite of the inevitable questions one asks oneself in such situations: How far can one go? How to avoid being sensational? Is it possible to express compassion when confronted by such total loss?

It was around three in the afternoon; the sky suddenly darkened, a real monsoon downpour started – heavy, drenching rain. The light turned to twilight, dramatic and beautiful, but somewhat tricky for photography. Nonetheless, I went on with my work, using a special lens, when I sensed someone behind me. I heard a voice murmur:

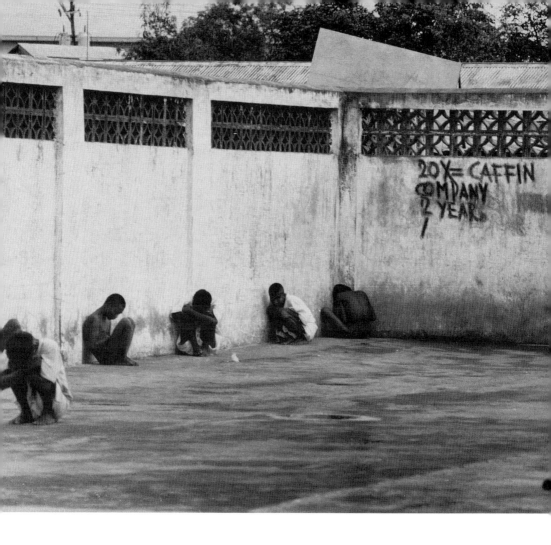

'Tri-X set at 1600 ASA, fifth of a second, wide aperture. Am I right?'

I whipped round and found myself face to face with one of the patients. Between 20 and 30 years old, he smiled at me slyly.

'I'm a Philippine photographer and reporter. I've worked for big American magazines. There was too much pressure. It eventually got on top of me and I ended up here. But who do you work for? You seem relaxed enough . . .'

True, I was 'relatively' relaxed. But perhaps one day, I too, in different circumstances, would 'go round the bend' to Sweet Unreason.

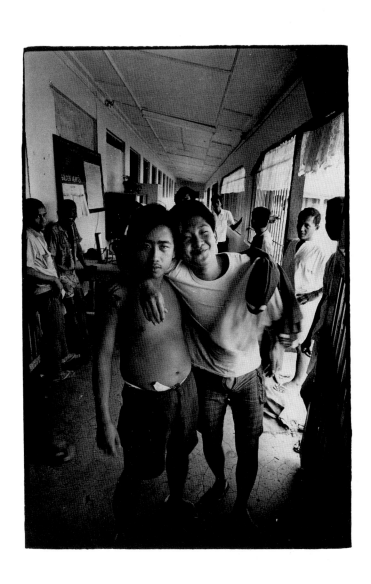

Cambodia, 1972

Phnom Penh. It was the end of the week, and I had finished off a small assignment of medical topics, the last of which had left me with a taste of ashes in my mouth. In itself, the job was nothing special; it involved documenting the running of a newly built hospital in the capital which had been equipped by China. As I went into the operating theatre wearing my regulation green apron, I felt that I was once again in my role as witness. I quickly took stock of the strategic corners from which I could carry out my job without trespassing on forbidden territory: the sterilization area and the open space needed by those involved in the operation. Everything was going smoothly. This was something I was accustomed to; everything seemed to be as it always was. But suddenly, one of the nurses screamed and pointed at the electrocardiograph, on which the graph line plummeted to zero and stayed there. Every possible measure was taken to save the patient, unfortunately without success. Had there been a technical failure in the equipment or a human error on the part of the doctors? Or had the patient suffered heart failure? I had no chance to find out. I was politely but firmly asked to leave the operating theatre and the hospital.

That afternoon, I got a seat on the plane to Siem Reap, close to the famous archaeological site at Angkor. At the hotel, I was persuaded to hire a rickshaw driver as a guide for the following day, even though he only had a few words of English. A 'man-powered taxi', the 'Asian cycle' – a godsend! And a practically speechless guide – what a pleasure!

After breakfast the next morning, I found my driver waiting patiently by his vehicle. About 30, his face at once inscrutable and alert, he was dressed in dark shorts. The conditions of hire were arranged with some help from one of the hotel staff. I climbed in. And at this point, I began to feel slightly uncomfortable. There was an ambivalent relationship between the two of us: I was sitting

comfortably, protected by a canvas hood, while he, visible only from behind, was soon perspiring as he pedalled uncomfortably up the slopes. All I needed was a colonial solar-topee.

Gradually, I convinced myself, for better or worse, that I had nothing to worry about, and my scruples vanished. The magic of Angkor started to take effect. I spent the day in a enchanted dream. Stone fascinates me, especially when my mind is not encumbered by too many historical details. A tacit understanding was established between my guide and myself with the help of a frugal picnic we shared. When we got back to the hotel, using an interpreter, he invited me to spend the evening at a local festival, out in the country-side about ten kilometres away. My curiosity was aroused and I accepted.

We arrived at a strange place, alive with excitement. Candles provided the only light. Some of the men were armed and dressed like guerillas. My presence did not seem inappropriate; my guide pro-vided sufficient protection. But I took very few photos, and in the end I felt out of place. There was no hostility, simply polite indifference; clearly, I was in the wrong place at the wrong time. Later, I realized that it had been a meeting organized by the opposition, those who would be remembered for an infamous genocide: the Khmer Rouge. My guide understood my desire to return to my hotel; the rickshaw journey back into town through inky blackness passed in silence, but the tension was obvious.

Twenty years later, at the International Red Cross headquarters, coming upon an Asian employee in charge of the photographic archives, I asked him indiscreetly: 'Excuse me, but are you Cambodian by any chance?' (His face reminded me of someone.) I told him about my experience there.

'You're right, I was the chief Angkor guide at the time . . .'

He had had to flee his country in dreadful circumstances, making for Vietnam, and had finally landed in Geneva and found refuge there.

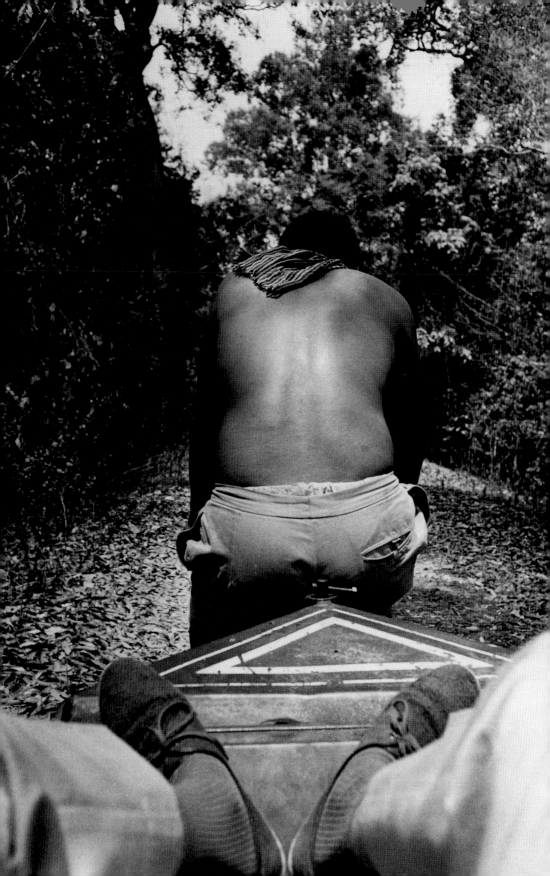

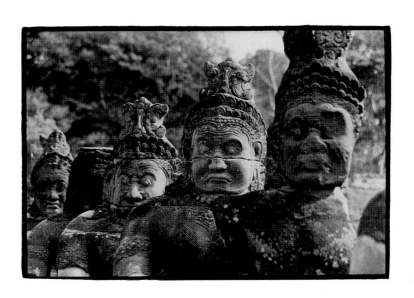

Algeria, 1973

One heavy sandstorm and the road would disappear – but that day, the sky was calm; there were no clouds. A cyclist would no doubt have one thing on his mind: to get back as quickly as possible, without exerting himself, to wherever he lived, away from this sun which was not yet at its height but which was beginning to bother him seriously.

Why is it that the desert holds such fascination for town-dwellers? Possibly because it seems to represent a total absence of life. And yet . . . life is present everywhere, but in an extraordinarily subtle form. There is water, but several metres under the surface; barely perceptible signs are there as evidence of this. Beneath every stone, a living being could be hiding, dangerous if disturbed. And the wind, that great landscape computer, that card-shuffler, needs to be interpreted, needs to have its excesses forestalled in time, needs to be listened to like a musical instrument.

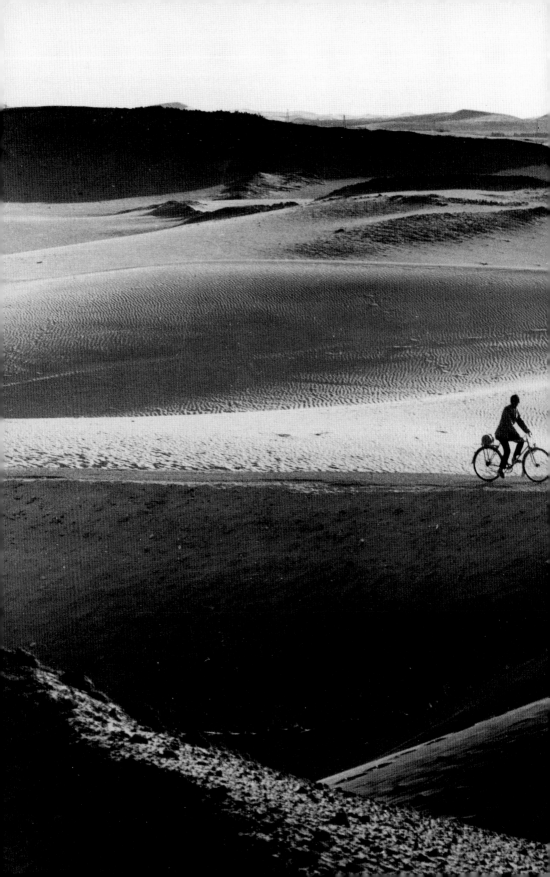

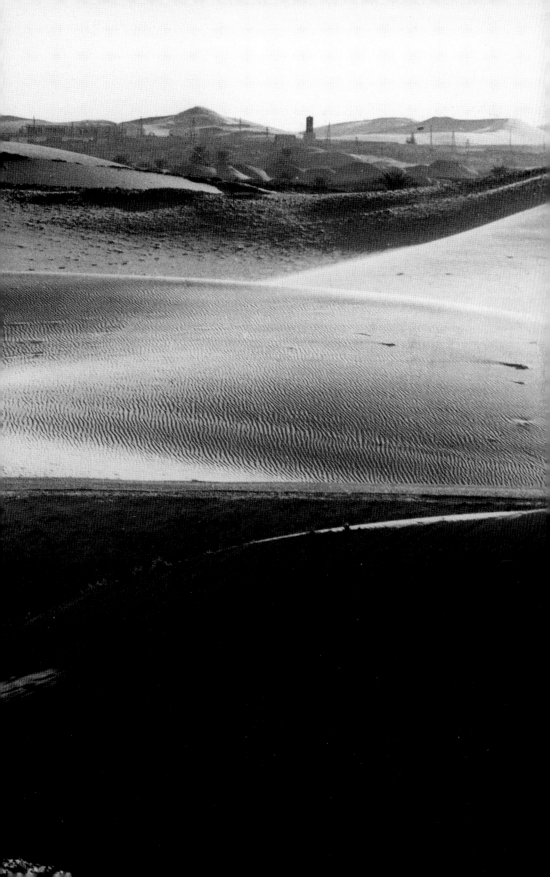

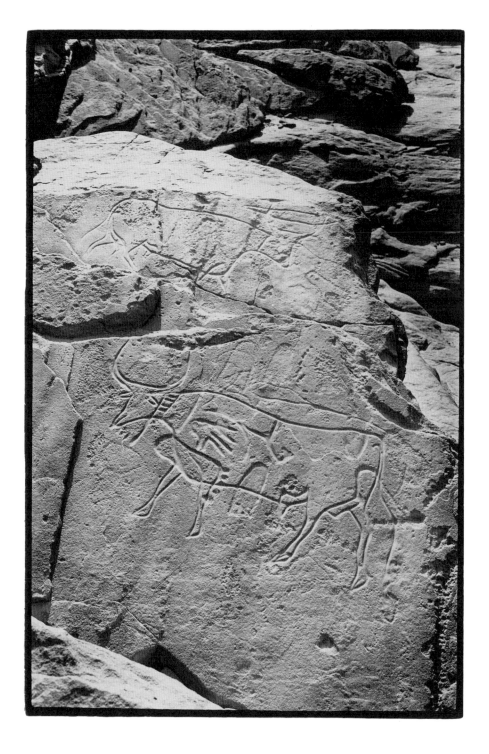

Sri Lanka, 1973

In the 1970s, the UN invested a great deal of energy and hope in family-planning programmes for developing countries (the phrase 'the Third World' was already becoming a thing of the past), sometimes without much thought. Crude mistakes were made, though they were not necessarily attributable to international organizations. It was very often local or international representatives who overstepped the mark, by not paying proper attention to local sensibilities and religious beliefs. A large family was often a source of pride and a way of insuring the future (our children will take care of us when we are no longer able to see to our needs).

But on a global scale, it was imperative that something should be done about the threat of a galloping birth-rate.

One example of a relatively harmonious family-planning programme that was well received by the local population was the Malipola project introduced in Sri Lanka.

Malipola was a plantation about 100 kilometres from Colombo with about 1,700 inhabitants who made their living from tea. Ninety per cent of them were Tamils (originating from South India).

The price of tea fluctuates considerably, like that of most basic produce from developing countries. The repercussions of this for the Sri Lankan economy in general and on the economy of the estates in particular are often disastrous. Other factors can aggravate this instability even further. For instance, there was a hostile film on British television, *The Price of a Cup of Tea*, which denounced the almost slave-like exploitation of local labour on the estates.

When I announced my presence at the Malipola estate, not only was the reception icy, but the guard at the gate was frankly aggressive. My photographic equipment, which I had made no attempt to conceal, caused him to react to me as if I were a rattlesnake. I tried to charm him.

'You must surely have been informed about my visit. Could you please check with the person in charge?'

The snarling gatekeeper made a telephone call from his cabin and returned in a decidedly better frame of mind. His rifle was no longer pointed at my chest.

'Show me your papers! You must have some form of authorization with you.'

Indeed, I had a letter, which he quickly inspected. The hint of a smile softened his features, and someone appeared immediately to conduct me to a luxurious bungalow. I had been sitting in a large armchair for a few minutes when a deep voice behind me asked: 'Can I get you some tea? Or whisky? We are very pleased to see you here.'

The choice of tea was easily made; the sun was still at its height, and a cup of tea seemed more appropriate in those surroundings than a glass of scotch. Conversation was warm and friendly, and a schedule giving pride of place to family planning was promptly drawn up.

The mobile clinic was parked in front of the tea factory. About twenty vasectomy volunteers were expected. Sixty turned up. Around thirty would be able to have the operation that day.

Another group of men had gathered to hear 'the gospel', namely various explanations of other forms of contraception. A hundred metres away, children observed the scene in fascination. Strangely (after all they were the ones directly concerned), women were practically invisible. Most were at the tea bushes or busy preparing the family meal. Further off, condoms were being distributed for use during the month before the vasectomy operation. The most common questions asked were these: 'If there are complications after the operation, who will pay?' 'What about unmarried people?' And most common of all: 'Do men run the risk of becoming impotent?'

Indeed, the decision to have a vasectomy is an enormous one, and one that cannot be reversed. The men must have felt that they were up against a wall, with very little sense of what to do. The reward? It was very often trivial – a radio, for example. A less constricted future awaited them, but one outside the ancient family and tribal traditions. And did their wives approve of finally being protected from endlessly giving birth?

I felt very shaken when I had completed my documentation, not by the clinical side of it but by the futures of men who had very little choice and by my own inability to remain outside the situation. What decision would I make in their position? Would I go for the short-term benefits or place my faith in favourable developments that might bring about positive change? I was treated to a second cup of tea, which I drank very slowly with no attempt to fill the gaps in the conversation; then I took my leave. The price of a cup of tea . . .

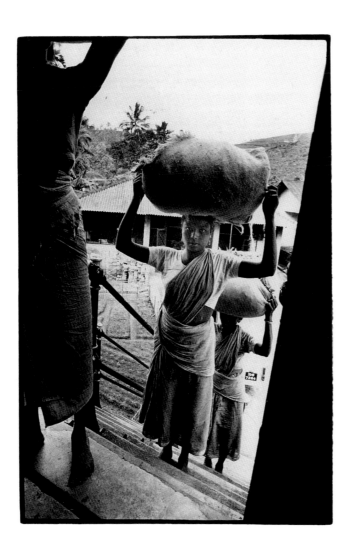

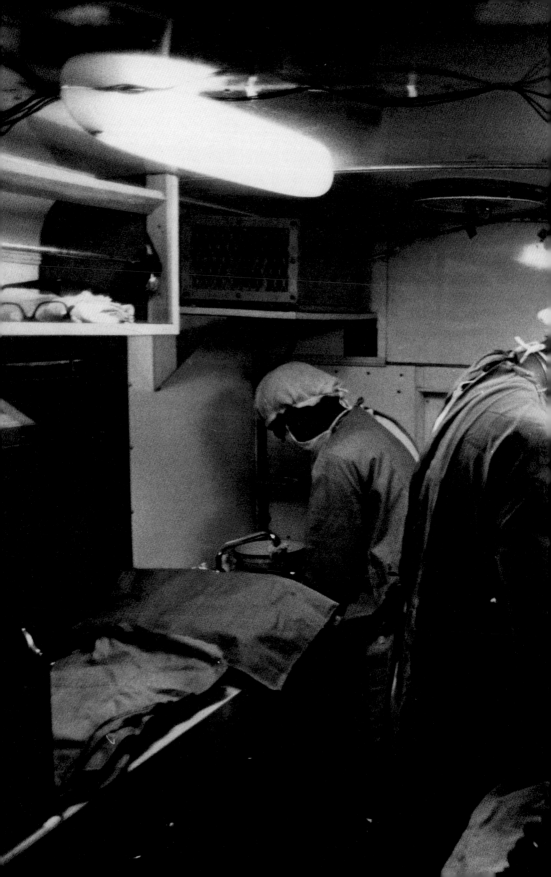

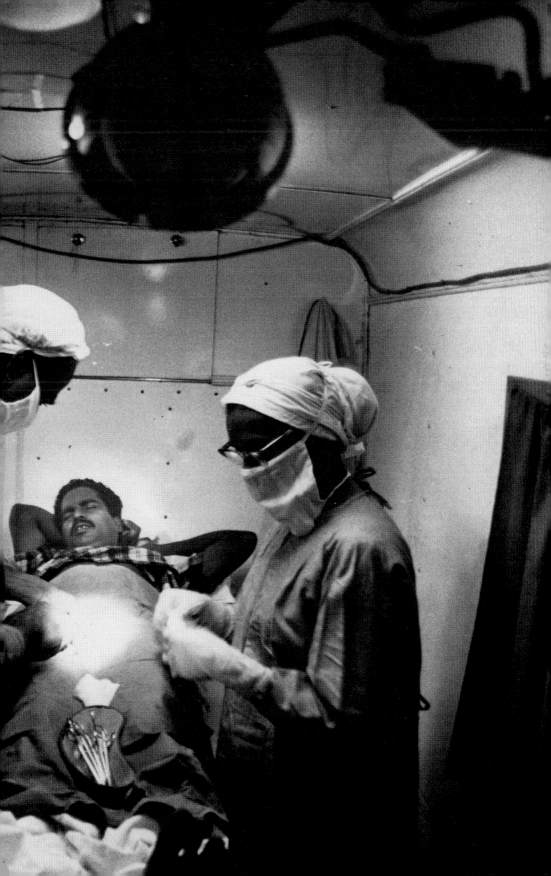

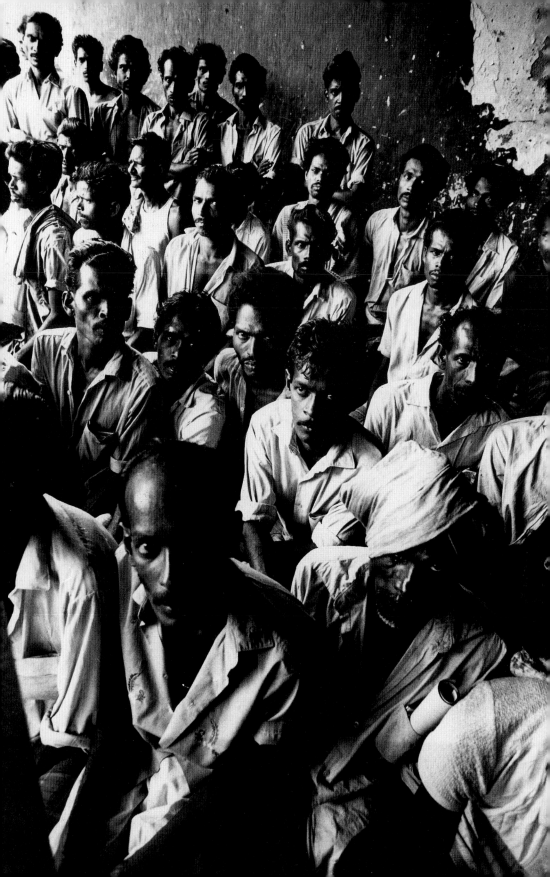

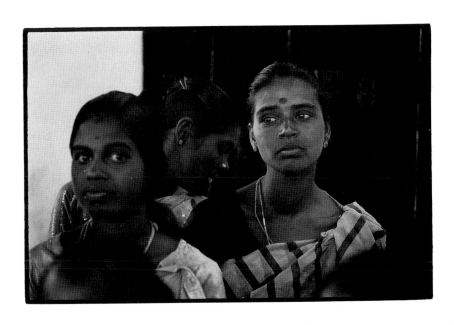

Allahabad, India, 1977

Towards the end of a winter journey across India, on holiday with my wife and with no professional obligations, there were ten days left before our return to Switzerland. Reading an English-language Indian newspaper, our interest was aroused by an article about the big pilgrimage to Allahabad at the confluence of the Indus and Ganges rivers. Every twelve years, this pilgrim gathering, known as the Kumbha Mela, takes place there. The event assumes added importance every 144 years (12×12), when it draws millions of Hindu devotees. Our own schedule fell in precisely with such an anniversary. All the pilgrims would converge on this holy place, carry out their ritual ablutions and seek contact with the holy men and women who were there for the event.

'Why don't we go to Allahabad too?' my wife suggested. 'For the last three weeks we've been steeped in a partly Muslim Indian world; this would give us a quite different perspective . . .'

'And where would we stay? What about food? How do we get around?'

'This article mentions a number of tents set aside for foreigners and journalists.'

'A few tents lost among the 12,000,000 pilgrims they expect to come, yes, it should be just what we need!'

Once we reached Allahabad, by train and rickshaw and, finally, on foot, with our bundles that were not so very different from the ones the pilgrims were carrying, we found the tents reserved for foreign visitors. At the station, we had been given valuable information, particularly about getting to the bathing place: at seven in the morning, we needed to note the direction in which the majority of people were going and follow the crowd; we would find our way without fail to the centre of the Kumbha Mela, the reason why women, children and old men had come from hundreds, even thousands, of kilometres away.

The following morning at the appointed hour, we peeped out of our tent: there was fairly dense mist everywhere, covering people and tents in a soup-like substance that reduced everything that moved to no more than a blurred shape.

There was no noise to speak of, more of a faint murmur, muffled and reassuring. The people filing past our tent without looking backwards, slowly but unfalteringly, knew where they were going. They have prepared for this moment for months, for years, for this culminating point of their lives: immersion in the sacred waters.

We almost found ourselves sucked into the flow of the crowd, irresistibly so. I have been known to panic when I find myself un-willingly plunged into dense, purposeful crowds: the Tokyo metro at rush hour, political demonstrations in Calcutta. Here there was no trace of panic. We gradually fell in with the serene movement of the crowd. The experience was at once surreal and remarkably down-to-earth. No-one paid any attention to us, and there was no xenophobic reaction or ostracism on religious grounds. This silent procession with no particular sense of time to it made us feel somehow grateful to be included, for being part of it . . . God knows, I am normally totally allergic to organized marches, which can so easily fall into step with military ones. But here no-one was shouting orders; we could fall out of line whenever we chose, and decide to stand at a distance – the distance of Westerners, Christians and city-dwellers.

The procession slowed gradually, and the crowd, which had been disciplined up to this point, started to disperse into small groups. We had nearly reached the confluence of the two rivers, and everyone was trying to get near the water. For ethical (and hygienic) reasons, we did not follow suit.

We were there as witnesses, as sympathizers; I had a camera in my bag, and I began to put it to professional use, discreetly at first, then more freely, since people were paying little or no attention.

Every 500 metres, there were watchtowers occupied by soldiers who were there to ensure that events went off peacefully. I was taken off to one of these, flanked by two uniformed men with impassive faces. What had I done wrong? A high-ranking officer explained in halting English that I had overstepped my rights and taken photo-graphs of *naga sadhus* (naked holy men with painted faces). He asked me to hand over the film, and I categorically refused. My wife had

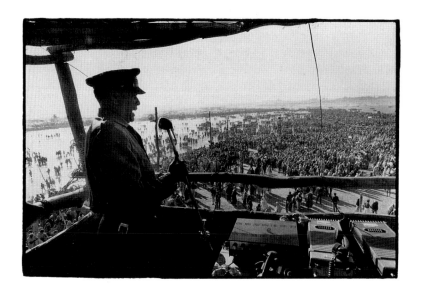

joined me. Using her powers of seduction, she persuaded these men on duty that I was innocent of the charge against me. It all ended with an exchange of visiting-cards and fond farewells. Had I been on my own, it would have taken me much longer to extricate myself from this tricky situation.

Honour was safe on both sides, and we took our leave and went back down to the river. The tense atmosphere of this encounter, the drawn-out uncertainty about its outcome (or the haggling process), had destroyed any further desire to take photographs, and we continued our dazzled wanderings like sleepwalkers, halfway between dream and nightmare. After a while, I dug out my camera again; there had been enough time for my wounded pride to recover, and I did not have sufficient strength of mind to tell myself bluntly: 'I'll just be an observer – I don't need to take photographs.'

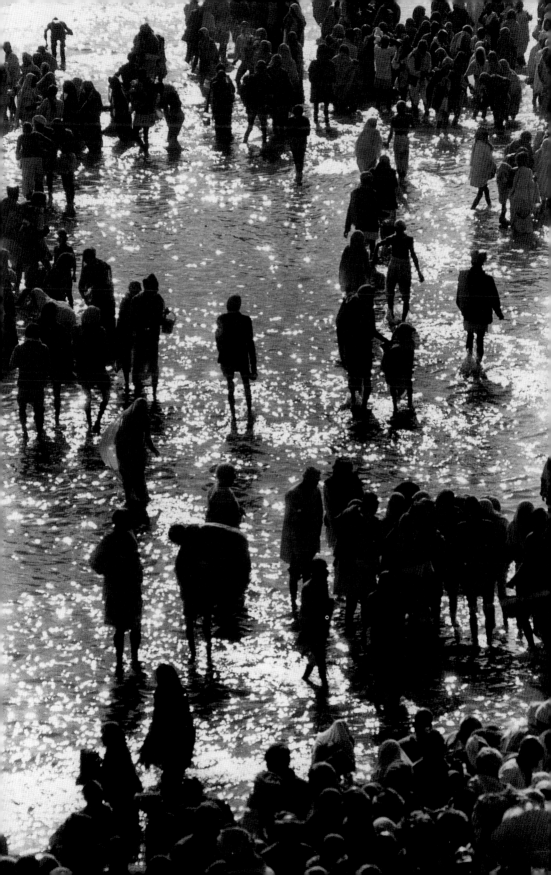

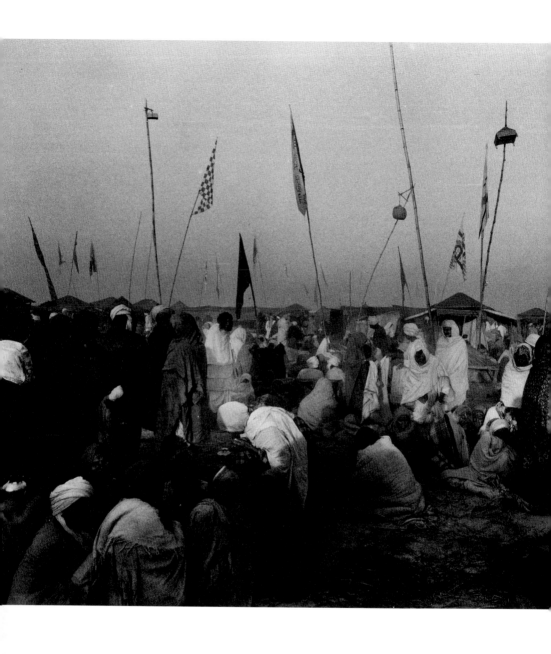

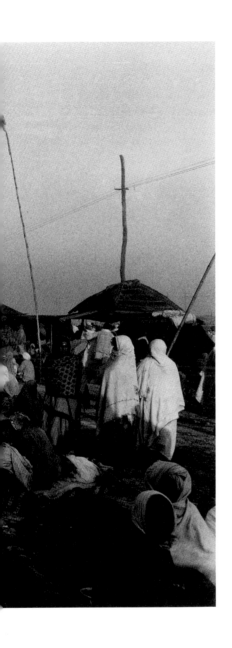

Orgosolo, Sardinia, 1976

On holiday in Sardinia with the whole family. A hotel on the south-west coast had been warmly recommended. It was our first stop after the ferry crossing. The children were enchanted. There was the sea, a swimming-pool, numerous sources of entertainment. We the parents were less thrilled: it was not a luxury hotel, but the prices were slightly high for us. Also it bore a vague resemblance to the Club Méditerranée with its helpful organizers who were just a little too helpful. But we did not have the courage, or rather the energy, to change our minds.

The evening meal was copious and delicious, a sort of cold buffet where you made your own selection and ate as much as you wanted. Just the thing for a family with a large appetite. Afterwards, a confident man with the superior bearing of a swimming instructor made the following announcement:

'Ladies and gentleman, you know that there is an excursion tomorrow. We have arranged an exciting trip for you to the village of Orgosolo. You must have heard of the famous film *The Bandits of Orgosolo*. That is where we are going. There's no need to worry; there is practically no danger involved. Times have changed, and, if need be, we will be there to protect you. The coach will leave at eight in the morning.'

I was foolish enough to provide my family with a brief translation of this speech. My eldest son was immediately carried away with enthusiasm.

'Terrific! We are going, dad, aren't we?'

A slight hesitation on the part of the parents, less keen on organized trips.

'You're not frightened of the bandits, surely?'

We were trapped.

The coach left around dawn the next day. Most of the passengers were Italians from the mainland, along with a German-Swiss couple

and lots of children, everyone in really high spirits, as though we were off to some special sort of Disneyland.

The journey on winding roads took longer than expected, and it was nearly midday before we came in sight of the village. The coach stopped below a long stone building, half manor house, half farm, one of those anonymous architectural wonders. Two other tourist coaches were already parked there. We were taken into the court-yard where an appetising smell of grilled meat floated in the air, and everyone was told to find somewhere comfortable on the ground to sit and eat. The food (lamb done to a turn) and wine were brought to us by silent men who moved with rapid, precise gestures. We were told that they were 'local shepherds'.

Some of the children wanted Coca-Cola and ice creams. There were none. Most of the adults did justice to the meal.

'Natives' and visitors eyed each other obliquely. Apparently, there was no common language. Then one of the shepherds slipped off and came back smiling with a Jew's-harp. He started to play, very quietly; then the rhythm speeded up, soon reaching a devilish pace. A kind of round dance was organized, shepherds alternating with visitors (mainly female ones) and holding each other's hands in a sort of hectic *picoulet*.

I had taken out my camera and was looking for a place to get a bird's-eye view of the scene. I climbed up and installed myself quietly on a roof-top. From there, I got a glimpse of the back of the house, into the wings as it were, and saw something which made me feel very ashamed. The families of the shepherds who were busy flaunting themselves, dancing the farandole in the courtyard, were down there greedily finishing off the left-overs of our meal.

There were three commanding hoots on the horn from the coach drivers. The dance broke up, and everyone boarded the coaches again.

We went back to Orgoloso a few days later, without a guide and free to do as we wished, to study the extremely fine political murals inspired by Diego Rivera of which we had only managed to catch a glimpse from our coach. The interlude of a few days before, the so-called folkloric 'happening', had made no mark. No-one paid any attention to us; we belonged to that category of passing visitors who do not even scratch the surface of village life, discretion being the order of the day for all concerned.

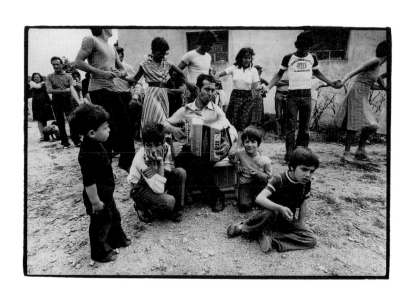

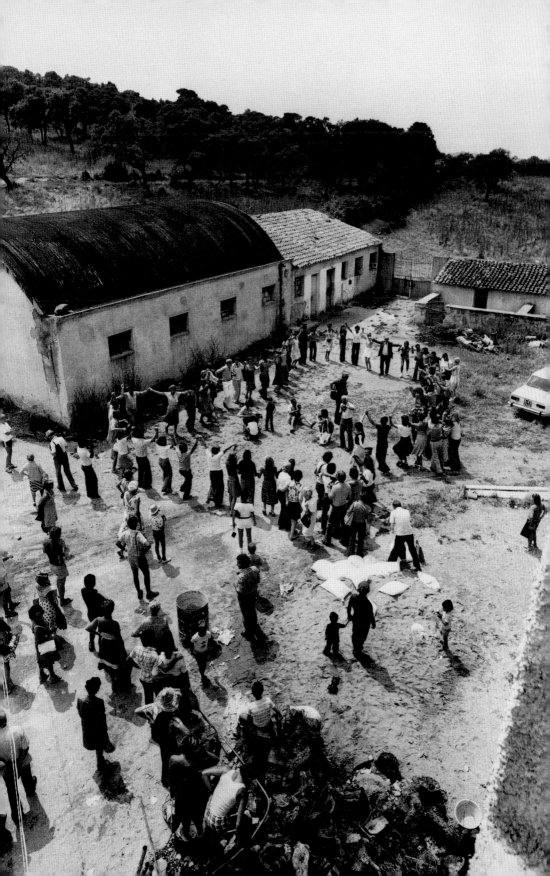

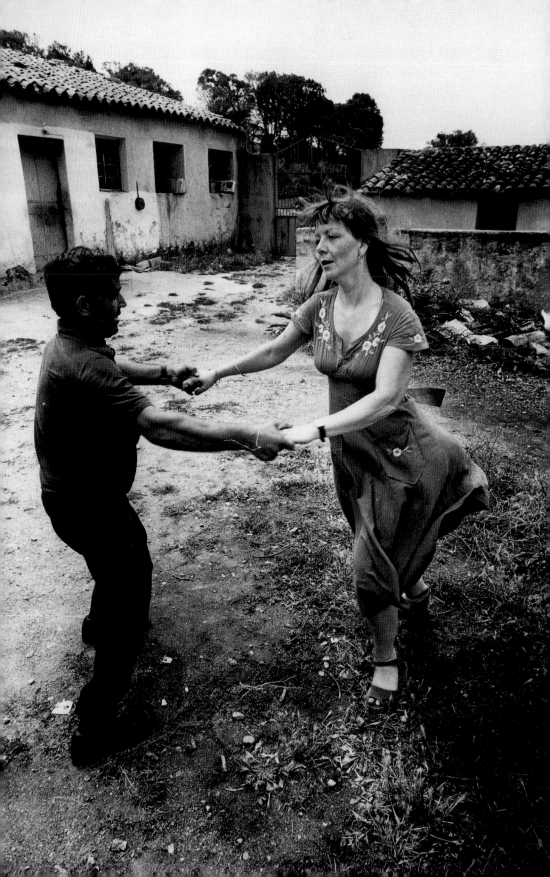

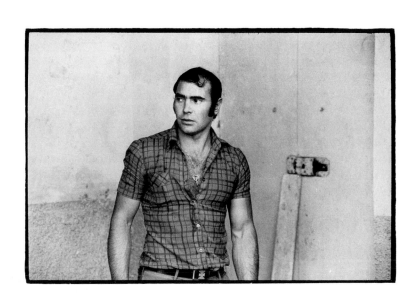

Sommand, Haute Savoie, France 1979: Père Nicoud

I had been hanging about this place for just under two years, making surprise visits, usually brief ones (they nicknamed me 'Mr Whirlwind'). I was making sketches of landscapes and farmers, clouds, too, and cows. At first, there was some distrust: 'What is *he* doing here?' Gradually, the ice melted. There had been no unpleasant photographs in the local press, and people knew who I was: 'There's that photographer from Geneva. What on earth can he find to interest him here?'

My hunting-ground was in Haute Savoie between Mieussy and the Sommand plateau, about 40 kilometres from Geneva. Why had I chosen it? An English writer-friend, John Berger, had come to live there, in a very simple house, and was putting together a work of fiction-based-on-fact about the mountain peasant community that was dying out there. We had already worked together on several books in which the text and illustrations relate to each other in a complex manner. But this time, there was a problem.

'I'm very sorry, Jean, but I shall have to do without your photos this time. I'm not writing a documentary book, and the reader will have to see my characters in the imagination and shape them accordingly. In any case, you can imagine the effect on my neighbours if they were to recognize themselves – it doesn't bear thinking about! But we shall need your pictures for another, more general book, which has been in my mind for some time now.'

It is not a central concern of mine to get my photographs published straight away for some specific project. When I have a good subject, or rather, when a good subject has me in its power, I wait for the fascination, or at least my sense of interest, to die down.

But here I was really caught up in my project. To begin with, by the unfolding of the seasons. The first snow, which I had missed the previous year. The infinite renewal of the stormy summer skies. The

130

work in the fields carried out in different circumstances each year. In addition to these predictable parts of my programme, there were other, unpredictable events to which I was sometimes summoned: a burial, a baptism, an old folks' reunion, even a wedding. And at these events, I was expected to show proof that I knew how to do my job well. There were no angry demands; I would be asked delicately: 'So the photos haven't come out then?' Once they had been printed, I needed to make a careful selection, to 'censor' the material so as not to offend the hidden sensibilities of country people. And of course, there was no question of being paid for my work with money. That would corrupt the relationship between us. But I would find rewards in the back of the car: a crate of plums, a salami, a bottle of home-distilled spirits. Good, old-fashioned payment in kind, for which I have a soft spot.

Among the characters I particularly liked was Père Nicoud, a 70-year-old man with an apparently inscrutable face, whose mischievous expression actually tallied with the 'kind' wrinkles inscribed around his mouth and eyes and on his forehead. He did not have much to say, but the few words he did contribute to the conversation were not without shrewdness and humour.

It was midsummer; the weather was ideal; most of the grass had been scythed in the pasture-land above a thousand metres and the hay stacked in the barns.

'Père Nicoud? You'll find him with his animals, somewhere between Roche Palud and Sommand. He normally doesn't get back for milking until late in the afternoon.'

I went off to look for him, and it was not long before I recognized some of his flock beneath some of the rare trees to be found in the pastures. Then I saw the man himself sitting comfortably on the grass leaning against a mossy rock. We said hello.

His dog was at his side, as untroubled and friendly as the old man himself. The two of them were extraordinarily serene. They seemed to be outside time, almost other-worldly. I sat down myself and attempted to ask a few harmless questions, a few too many. He asked: 'Do you want something to eat? I've got a bit of bread and bacon here.'

I accepted, deciding to fall into step with him and forget my city manners. I stayed there an hour, two hours, I can't remember;

towards five o'clock, it was time to take the animals back to their shed. I had not taken a single photograph. It would have meant breaking the spell.

A fortnight later, I went back to see Père Nicoud. Everything was different; the dog he had with him this time was my own, who had gone to take refuge with him for some obscure reason. He had run off in front of me and was anxious to show how pleased he was to be back in this place he found so magical, in the company of this ageless man who blended in with the landscape. The shepherd's own dog was standing at a distance, observing the scene without any apparent reaction. Our encounter that day was just as it normally was. Brief comments about the weather, about the probable forecast for the next day, about problems of getting milk to the dairy. In brief, we were at a far remove from the silent communion we had shared on my last visit. For me, that had been magical, as if he had given me something very precious, very private. And perhaps it was just that which made him feel, in retrospect, ill at ease: the violation of his privacy. It is not right to share one's dreams, even silently, with a stranger, a town-dweller at that – even a discreet one.

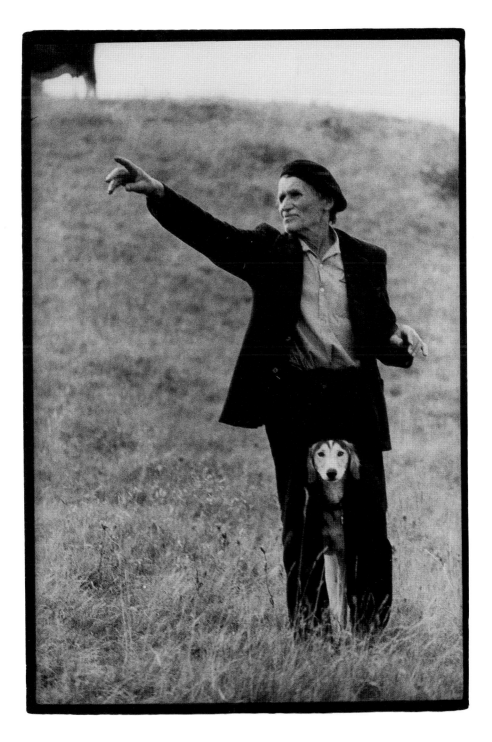

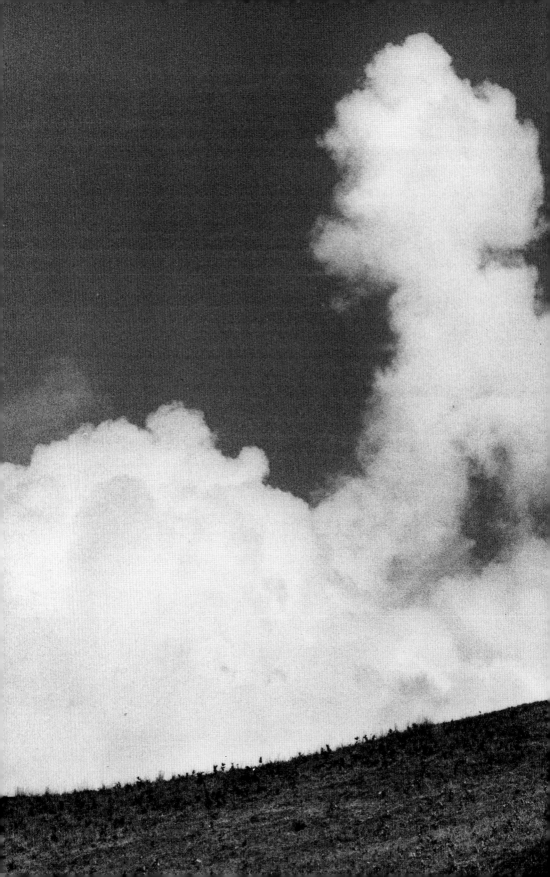

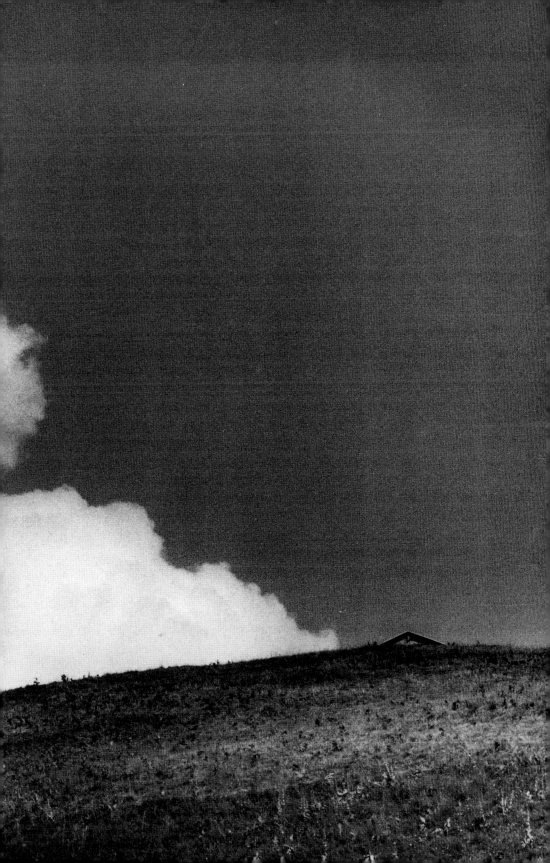

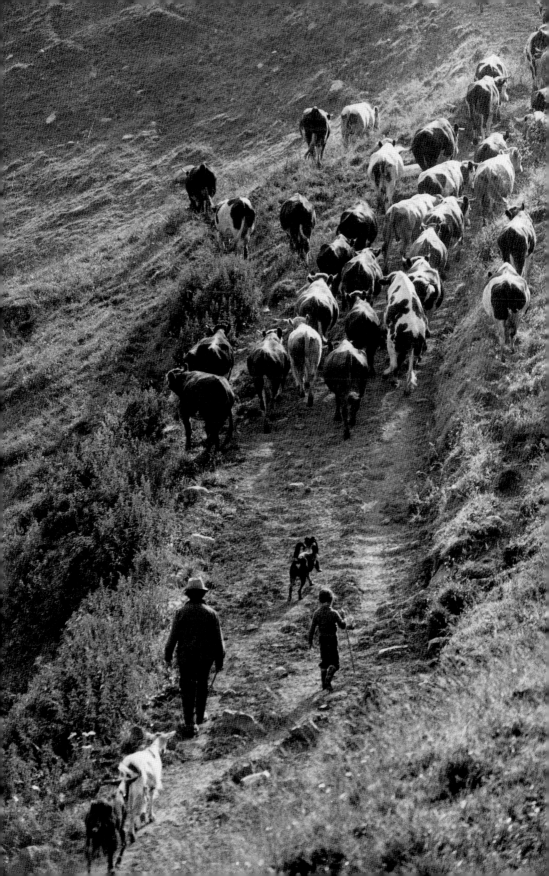

Nicaragua, 1986

A badly timed telephone call had just interrupted the radio broadcast of Bach's 'Coffee' Cantata. (I was somehow reassured by the fact that this great musician had himself at times been forced to compose to order). I was in my darkroom somewhat unenthusiastically running off a series of enlargements of photos from a report I had completed six months earlier. Almost relieved by the interruption, I picked up the receiver.

'Am I speaking to Jean Mohr, the photographer? I'm ringing about Nicaragua. I imagine you've heard of the Sandinistas. You're possibly even a supporter. We need photographs, really good ones. Your name came to mind. We need someone with a great deal of tact and open-mindedness. Someone with feelings!'

The offer, for this is what it was, was followed by a meeting in a café near the university. The Swiss-Nicaraguan Association at the university wanted me to go to Nicaragua. They would cover expenses.

My side of the bargain: to produce photographic documentation in colour, as I saw fit, of daily life under the Sandinista regime.

Twelve of the photos would be chosen for a calendar to be published in Switzerland. The proceeds from the sale of these calendars would be used to build a school in Nicaragua, near the Honduras border.

For me, Latin America was virgin territory, a universe that was both fascinating and filled with evil spells.

The financial terms of the contract might have seemed rather basic, but the jobs I take on cannot be dictated solely by security or income. Again, there was the final goal of the enterprise: helping to build a school.

I landed in Managua a month later. The welcome was almost stereotypical: 'Greetings, comrade photographer! Welcome to our tiny country. You will see some fine things during your stay . . .'

I was taken by jeep to a friendly little boarding-house, but there

138

was nothing fine about it. Still in power, the Sandinista regime was struggling to fend off ongoing attacks from the Contras (supported by the Americans). The economy was very unstable. You could buy almost anything you wanted at the Intercontinental Hotel where journalists and businessmen stayed, provided you paid in US dollars. Elsewhere, cigarettes were being sold singly, like fruit and vegetables. The capital had been badly affected; ruined buildings alternated with superb murals depicting revolutionary themes; the neighbourhoods that had not been rebuilt were being invaded by long grass and turning into rather unsettling tracts of no-man's-land. Nonetheless . . . I went everywhere in this city, carrying my camera, without the least fear, without encountering the slightest hostility. Yet when I think of the Bronx, Brooklyn, Chicago, even Pigalle or East Berlin before the Wall went, a shudder runs through me.

In the city centre was an abundance of small trades. Numerous shoe-shine boys argued over their patches. I must have turned ten of them down (the guilty feeling one experiences the moment contact risks turning into some sort of colonial relationship). Finally, I gave in and installed myself in a rickety chair. This kid could not have given two hoots about my scruples; he would earn his small fee, that was the only thing on his mind. His small fee, plus the tip for the photograph I had taken of him, during which he did not move a muscle.

I left the capital to visit the countryside, encountering the occasional road-block towards the north and east, as well as the occasional decisive injunction: 'You will have to turn back. We cannot guarantee your safety.'

The journey proceeded without a hitch nonetheless; photos accumulated of their own accord; my Spanish improved; I felt surprisingly at ease. I eventually found myself back at Managua airport, slightly dazed at the idea of returning to Switzerland. And it was difficult to get used to being back there; it was bound to be.

And the school in the north-east? Is it functioning? The calendar was published, in any event. I flick through it sometimes, filled with gentle nostalgia; each picture recalls some aspect of that journey, whose wonder and familiarity I was unable to appreciate with any immediacy.

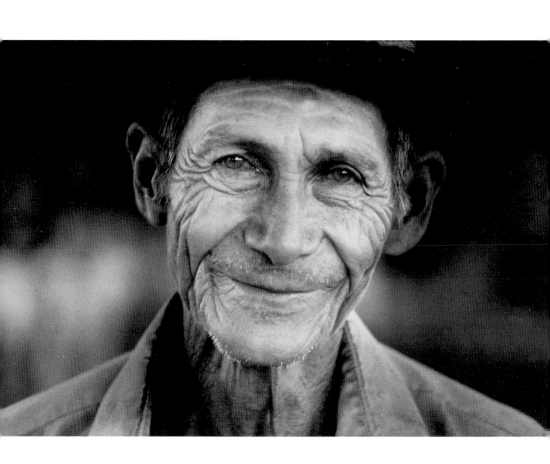

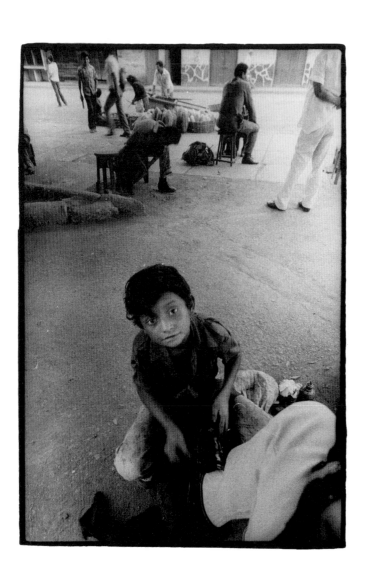

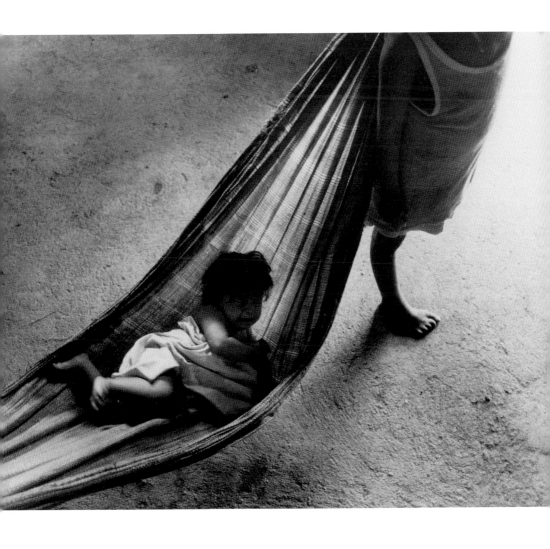

Sydney, Australia, 1988

Australia . . . the fifth continent, the one furthest from Switzerland, and often the last one to be visited in one's quest around the world. So far, nothing had justified such a journey; the media were barely interested. Sydney, an endlessly expanding capital? Kangaroos, not even as animals faced with extinction? The last natives, the Aborigines, reduced to the same fate as the Native Americans? No, definitely not: a trip to the other side of the world was hardly necessary, at least from a professional point of view.

And then a letter from my youngest son, who had been living in Australia for several months, arrived in Geneva: 'Dear parents, Michèle and I are getting married. It would be wonderful if you could come to the wedding . . .'

It was more than an invitation, this affectionate injunction to parents to come and celebrate this occasion on the other side of the world.

The flight from Geneva to Sydney is a very long one, even on a 747, and our ticket was arranged so that we could make a four-day stopover in Hong Kong ('Would you like to book a hotel?' 'No thank you, we'll make our own arrangements when we get there'). We were used to making our own arrangements on non-professional journeys, out of a liking for the unexpected or a sense of adventure, exciting or otherwise. (The number of bad experiences to suggest that our attitude was misguided has been negligible.) This time, things nearly turned out badly. When we'd failed for the twelfth time to find accommodation, the taxi-driver who was ferrying us around from hotel to hotel observed: 'You won't find it easy to get accommodation – there are lots of conferences and courses on at the moment – but I know a boarding-house that will take you. It's very basic.' The place was decent enough, slightly kitsch, but we were growing tired.

'You want the room for how many hours?'

Astonishment, misgivings – but weariness won the day.

'Until tomorrow morning, if that's all right?'

The manageress handed us the keys. The surprise on her face gave way to admiration; we were not exactly a young couple who just couldn't wait!

A few days later, we flew off to Australia. The marriage ceremony reflected the spirit of the young couple themselves, both actors. The decor: a beach at a remove from houses, a tent for the reception and a variety of music which created an atmosphere that occasionally evoked Fellini or Etore Scola but was decidedly more jolly. The bride's parents were of Chilean origin, and that in itself guaranteed an unrestrained, bracing atmosphere. I was familiar with my son's pronounced taste for creating a setting – after all, he had chosen to make his career doing just that! Real fervour alternated with bursts of improvisation, and there was also a contribution from a woman priest, in no way out of place, perfectly attuned to the festivities. My wife and I were also attuned to it all. More than that, this marriage enchanted us: the young couple were radiant, having chosen to get married independently, with no pressure from anyone else. And the future? The word has no meaning in the theatrical world, which lives out its passions day by day, struggling to survive, or at best to build a tenuous career.

I watched my son moving around in this multiracial crowd which had come to celebrate and enjoy itself. He seemed totally at ease in his dual role as master of ceremonies and as the man who, together with his wife, was being fêted. I felt enormous affection for him, and yet I saw him as something of a stranger. It was as if he had succeeded in erasing all of my family characteristics: restraint, an acute fear of ridicule, a lack of spontaneity. Was it the climate, the presence of close friends? It didn't matter. He was in the process of achieving his adolescent dream and proclaiming his enormous appetite for life and creativity to the world. Good luck to you, lad!

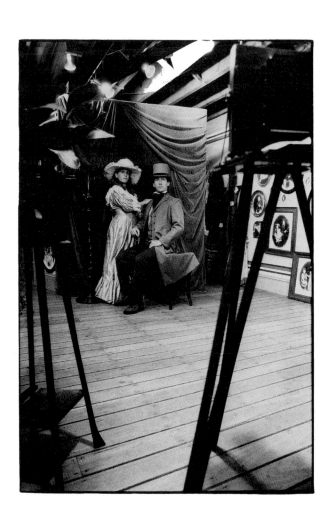

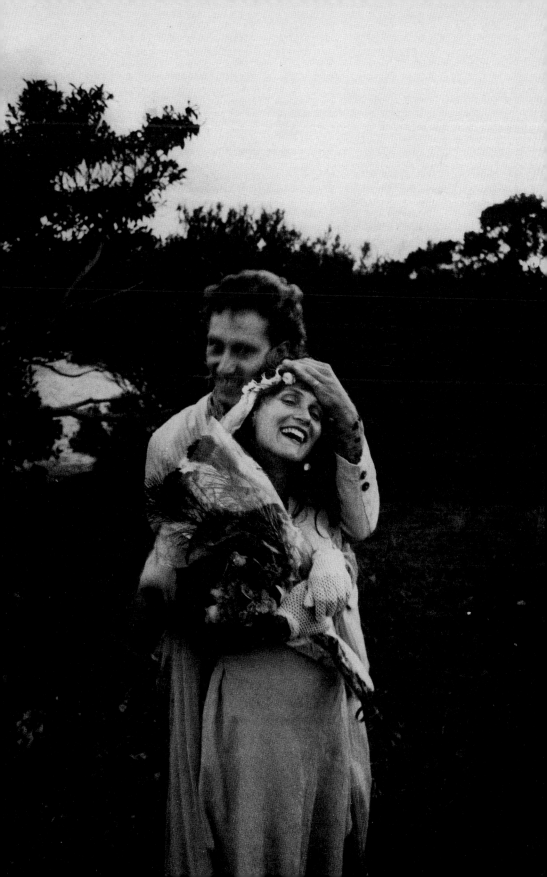

Karachi, Pakistan, 1989:
The Edhi Centre

A Pakistani journalist teaching at a New York university had said to me: 'If you're ever in my country, and in Karachi, then you must go and see Edhi and his centre for the homeless. It's fantastic! He's often been compared to Mother Theresa. I'll give you his details. If you mention my name, he'll be pleased to see you.'

My friend's enthusiastic remarks had aroused my curiosity, of course. He himself was out of the ordinary, a 'radical' militant well known in the United States in the '70s, torn between two cultures, generous, hypersensitive. Both the humanitarian work and the charity organizations sponsored by the UN made him angry, but Edhi – that was different!

The journey to Pakistan eventually materialized and proved rich in contrasts and adventures, from the Hunza valley to the Chinese border, Peshawar and its Afghan refugees, the bazaars of Lahore and, finally, Karachi, the slightly oppressive capital. Helpful friends everywhere, invaluable for avoiding blunders, preparing one for the unexpected, rekindling one's interest.

I had Edhi's address in my wallet on a folded bit of card. Was it really worth going to unearth this saintly man who had enough to do as it was?

A brief summary of his work: to provide free food for about a million people each day throughout the country, to run what amounted to an armada of ambulances in constant operation (local councils had long since given up dealing with the problem of road accidents) and to set up new centres in the provinces. How could he spare the time to see me, to reply to my questions (the naïve yet insidious questions of a Western journalist), to comply with my needs as a photographer?

And yet, within 24 hours, a meeting was arranged. An ambulance picked me up at my hotel and took me to Edhi's headquarters,

where he worked and slept. A kitchen table strewn with files, a camp-bed at the back of the room – this was the denuded setting, like the set for a Brecht play. I was given a warm welcome, and Edhi had enough English to explain to me how his organization functioned. We were occasionally interrupted by one of his employees asking for instructions or by visitors who had come with gifts: a live sheep, a basket of fruit, fresh vegetables.

'Are you ready then, Monsieur? Ready to take the photographs you consider appropriate to illustrate the immense needs of these people who are living at death's door?'

There was nothing of the guru about Edhi, a thick-set, bearded man of about 50; he reminded you more of a wily peasant with his feet firmly on the ground. He had no distinctive characteristics apart from his sensual lips and an extremely penetrating gaze.

My visit was spread over several days – it was both exhausting and exhilarating. With feelings that were often divided, questions that remained unanswered and also signs of rebelliousness. These centres took in a wide variety of people: the mentally ill, rejected wives, drop-outs, old men no-one wanted, victims of road accidents. Or young thieves who had been picked up in the towns for rehabilitation through apprenticeship in the organization's workshops. The life in these centres was anything but bracing; discipline was harsh and crowded conditions inevitable. But for those who had ended up here, it was at least a shelter, and in some cases provided hope for a new beginning.

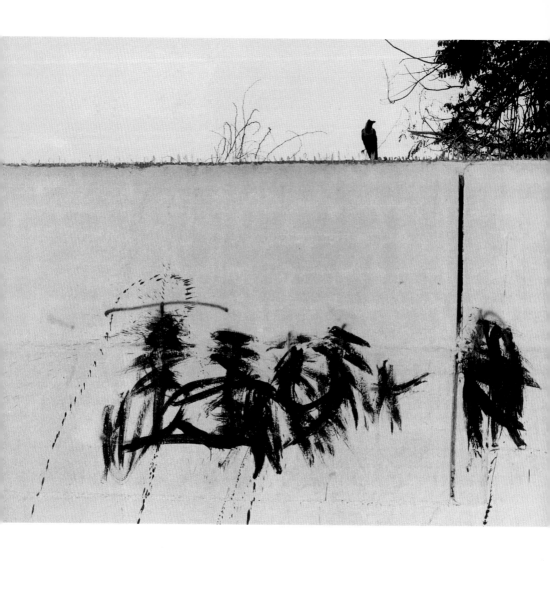

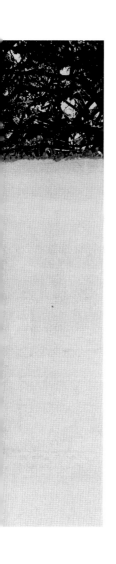

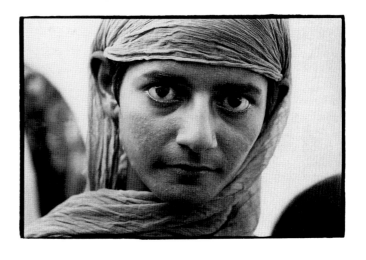

Southern Iran, 1991

Iran, a country of endless fascination but occasionally also of nightmare, depending on the year, the circumstances of one's visit, the season. I had been there before, twice.

On my third visit, I was sent by the International Red Cross. Iran had gradually ostracized itself from 'enlightened' countries by taking a leading role in the crusade against the West or, alternatively, with Saddam Husain's Iraq. All in the name of Islam.

I need hardly say that a Swiss passport and an International Red Cross assignment as a photographer were not the best of references. But the reason for my assignment went some way to restoring the balance. My subject was the presence and possible voluntary repatriation of Kurdish refugees from Iraq who had come to seek asylum in Iranian territory. As a former International Red Cross delegate in the Middle East, I felt relatively comfortable with this sort of situation. The newly set-up camps, others that had been dismantled, the overcrowded truckloads of families on the roads: new arrivals, or people trying to make their way back to Iraq. It all seemed like a great mass of confusion with blatant contradictions to it, but one thing was certain: there was an enormous amount of suffering among these refugees who had fled under direct threat to their lives, even if it meant leaving their homes and possessions, to seek uncertain asylum (to this day, the Kurds have no territory of their own and are not really welcome anywhere).

Just before the end of my mission, it was suggested to me that I should go and make a brief visit to the south of the country near the Iraqi border, where refugees were living in their thousands (there was no really accurate estimate of the numbers involved).

'Unfortunately,' I was told, 'we have not been able to get you a seat on a plane. You will have to travel by taxi. It's roughly 1,600 kilometres there and back.'

For the cosseted European, a taxi represents comfort, safety and

luxury. In Iran, it meant a 'bush taxi' – as it turned out, an enormous 1960s Chrysler that had possibly clocked up 500,000 kilometres. My travelling companion was a delegate who had recently arrived in the country. The journey was a real nightmare; the driver was forced to zigzag between lorries, there were several breakdowns, hastily repaired in a makeshift fashion, but there were welcome refreshment stops along the way.

We eventually got to Bassouda. An ideal setting for a science fiction film with a post-nuclear theme. The temperature during the day: around 50° c, and at night: around 35° c. The refugees were scattered over an area of several kilometres around the town. At first sight, there was absolutely no sign of them. There were smashed-up roads everywhere, but no signs of life. Gradually, children emerged out of these rat-holes and the rubble left by intensive bombing and shellfire, timid at first, curious and ready to jump back into hiding. Then there were shouts, of encouragement perhaps, almost joyful, directed at the other people hidden away underground. And on some of the faces, SMILES! We wielded no arms; our movements were restrained and in no way aggressive. We meant no harm. Once the fear had been erased, hope dawned and there was a radical change of expression on their faces. We became the Three Wise Men, the bringers of beneficial gifts. But our hands were empty, and all we were able to do was to make promises, note down names, arrange further meetings. Perhaps this would help to set in motion a process of reintegration into a more or less normal world in which the idea of dignity might once again have some meaning.

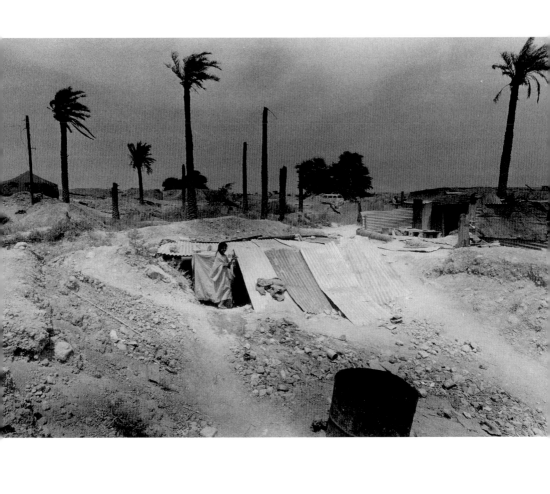

Moscow, Russia, 1992

Moscow, 30 April – in other words, just before May Day, a holiday that is perhaps less sumptuously celebrated now than it was during recent decades, but one on which no serious work can be expected to get done.

'Work'? For me, the word needed to be put into inverted commas. I was going to interview, in German, an old Russian art collector whom I had met in Moscow twenty years previously and, while I was about it, to take some photos of him. The people doing the real work were the director, Willy H., and the cameraman, Hugues R., who were shooting the third part of a documentary about me and my work.

A few words of explanation. Willy H. had made me a very tempting proposal: he wanted to make a film about my life and work which would involve me choosing three places I would like to revisit or discover. I chose East Pakistan, Japan and Russia. Why? Pakistan, because a first visit to the northern provinces had left me with a distinct desire to go back. Japan, because my eldest son had gone to live there, and a tour by the Orchestre de la Suisse Romande offered me the opportunity to revisit the country. And Russia? Here my reasons were less clear.

Twenty years earlier, I had spent a month there, and things had ended badly. The day I left for Switzerland, I had been subjected to a thorough search at Moscow airport, and all my films had been confiscated by plain-clothes officials. (Police, customs officers, KGB? They were polite but firm.) The only photographs that were returned subsequently were those commissioned by the UN. What were the official reasons for this? I was criticised for my interest in graffiti and the work of well-known artists who were not officially recognized, the so-called 'cellar-club painters' (later they were described as dissident artists). I was even called a pornographer because I had photographed paintings of nudes. All my attempts to recover these

photographs ended in failure. This meant that I had to break my contract for a book with the projected title *Moscow– New York*. In brief, it was a total humiliation. And to think that I could have avoided this catastrophe by arranging for my films to be taken out of the country by some circuitous route!

The reason I had chosen Russia, and more particularly Moscow, for the last part of the film was as a sort of quest, a desperate attempt to recover those colour slides (representing a month's work in Moscow after a month's work in New York), those images which had gone from my memory but were perhaps buried in some KGB basement, filed away under goodness knows what administrative heading. Once again, my attempts failed. It was like a wild goose chase, somewhere between farce and Kafka. There were three possible ports of call: the Customs Office, the Swiss Embassy and the KGB.

'We're very sorry, but you will find nothing here; it would be better to go and ask at such and such a place . . .'

If only it had been possible to record those flat exchanges, to film the stuffy expressions on people's faces, but this was still the Soviet regime, and the old traditions prevailed. The key word was still *nyet*. It was like chasing something without ever really knowing who was running the show. We were determined to capture scenes that would illustrate the points we wanted to make, even if – especially if – they were humdrum: Kafka was the obvious reference point. But Kafka represents not only the exposure of absurdity in the everyday, but someone who is also a fine writer. For our film, we envisaged a commentary reduced to bare essentials, excluding literary references, to back up the visual impact. We were faced with government officials who had good reason to suspect that our motives were not exactly innocent, but who did not dare to obstruct our progress in an overt way, for détente was the order of the day. So it turned out to be a game of cat and mouse, with each side convinced that they were the cat!

Happily, there was another side to our reporting: it covered the daily life of the Russian capital under Gorbachov, in particular first-hand accounts of 'dissident' artists and their friends.

Many such people had chosen to go into exile. One of the best known, the sculptor Ernst Neizvestny, had gone to New York, and I had been warmly received in his studio on the Lower East Side. Not

only warmly welcomed, but provided with copious quantities of beer and vodka as he evoked, in a voice laden with emotion, his country, his years of persecution, his row with Khrushchev and, finally, his friends, the friends he missed most of all.

'America is wonderful; people are very kind to me, but their minds are so prosaic; they lack imagination, and at times that really gets me down.'

Some painters have emigrated to Germany or to other European countries. And then there are those who stayed or who have gone back. They are either too old or have managed to find some way of living under the harsh conditions imposed on independent artists. Finally, there are those who are able to live through any regime without letting it affect them, who are able to express themselves in spite of all the pressures, little caring whether they are understood or appreciated. They are not artists with cursed souls, simply total drop-outs, survivors who will one day be rediscovered, long after they have disappeared.

While I was visiting studios and listening to reminiscences of the (not too distant) past, pernicious thoughts crossed my mind. Did the man I was interviewing have anything to do with my unfortunate experience of twenty years before? How would I have behaved at the time, had I been a Russian citizen and an artist?

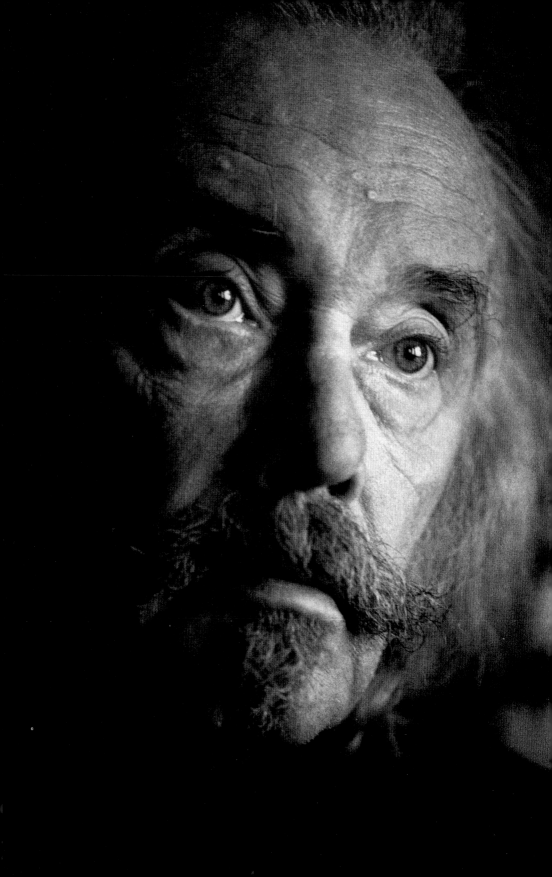

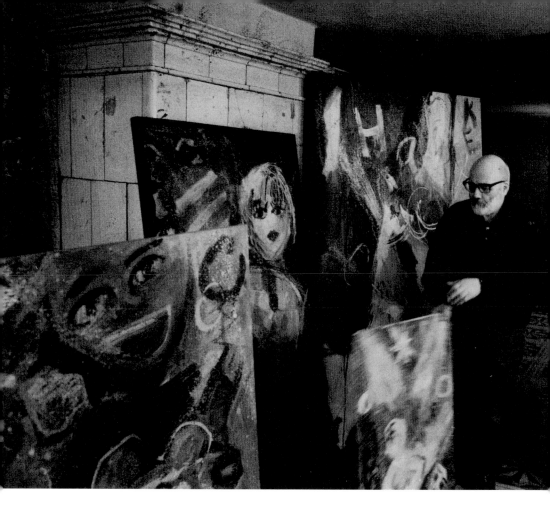

Outer Hebrides, Scotland, 1993

A very good title for a film: *Walk Me Home*. Unfortunately, the film will never see the light of day, or at least it will never be shown to the public, nor will it ever be fully edited and completed. Mainly because of the diverging views of the producers. The script-writer and leading actor: my friend John Berger. With Angela Winkler, well-known for her leading role in *Tambour*. The cameraman: a Russian who had worked with Tarkovsky. The director: a Scottish art-history professor, a muddle-headed character with some occasionally bright ideas – a strange man.

I had seen the team at work in Hamburg over a period of days when they had first started shooting. The atmosphere had been slightly electric, but this type of collective enterprise rarely engenders calm.

John had asked me to join up with them later on a small island in the north of Scotland, so that I could finish taking photographs of the shooting.

'A few days will be enough. We need, most importantly, to capture the atmosphere, to get a few representative shots. You know the sort of thing I mean . . .'

I did. There was no possibility of misunderstanding; that was why we got on and worked so well together.

'The island is almost at the edge of the world. I'll explain how to get there.'

Though complicated, the journey turned out to be a genuine pleasure trip: a jumbo jet to London, a more modest aircraft to Glasgow, by bus and ferry across to an island off the north of Scotland, by taxi to a simple house where I was given a friendly welcome by a couple in their 60s. The wife, I learned later, had been one of John's colleagues at a London art school. More than a colleague perhaps: in short, they had become good friends. After the obligatory cup of tea, she was the one who took me by motorboat to

165

the little island they owned, depositing me on the beach with my camera bag and a small rucksack.

'Can you see the white house about 500 metres over there? It's the only one on the island; you can't go wrong. Good luck!'

The motor was still running. She smiled, and the boat set off again for the main island.

I felt decidedly excited; it was as if I was sneaking into the film as it was being made. It was all there: the ghostly setting, the half-light, the almost total silence.

I eventually found the room were the team had gathered. About fifteen of them. The place was thick with cigarette smoke, the faces inscrutable, the tension palpable. My intrusion was barely noticed; for some it was welcome, for others completely irrelevant. They seemed to be discussing essential themes and the decisions that needed to be taken about the rest of the shooting. It was written all over John's face that he was having a bad day; from time to time he stammered, tugging at his thick hair as if it might provide him with a solution. Eventually, he noticed me, stood up like a sleep-walker and introduced me to everyone. Having said hello, I attempted to fade into the background, restricting myself to taking a few discreet photos.

Work resumed on the film the next day; the previous evening's crisis seemed, if not resolved, then at least less burdensome. Two days later, I took the boat back to the main island, then travelled on to the mainland. I had experienced some very strange moments, some exciting, others disconcerting. On that tiny piece of land were talents, skills and the will to succeed, the ingredients for a cinematographic masterpiece. So what grain of sand had got into the works?

Chiapas, Mexico, 1996

My first visit to Mexico had been confined to Guadalajara, a big industrial city spread over a wide area with an attractive, bustling centre. I had been invited by the university to give a photographic seminar that left me very little free time. But the warm welcome and the friendship I encountered had left me with a great desire to get to know the country better.

The following year, the same institution invited me again. Unfortunately, I was forced to decline the offer for medical reasons. Horribly frustrating!

In short, I spent that Christmas cosily at home in Geneva, getting well. But I was sure of one thing: my intention to spend the following New Year in Mexico with my wife. Letters were exchanged. Alas, there was a serious economic crisis, a draconian reduction in the cultural budget, and the conference had been cancelled, but . . .

'You are always welcome here, so why don't you come and see us when you come to visit the country?'

So we were left free to plan our trip as we wanted to. We decided to hire a car, to do some of the journey by air and to concentrate on the Chiapas region, which had been made famous by the *zapatista* rebellion two years earlier, led by Deputy Commander Marcos, a figure much loved by the media.

I had several telephone numbers that would enable me to get in touch with people closely involved with the rebellion, but none of them were really very useful. At our hotel in San Cristobal de las Casas, they suggested the next best thing – a paid 'safari' on horseback which would give us the opportunity to meet guerrillas in the jungle. Not exactly what we had in mind!

Then, somewhat by chance, we learned that there was to be a big rally at Oventic in the mountains to celebrate the second anniversary of the rebellion and the movement's evolution into a more peaceful, political phase of its development.

The information bureau gave us identity tags, passes and directions. Among those who had come to the bureau for the same reason as ourselves were Americans, a few Germans and even a couple from Geneva. Journalists, sympathizers, human-rights supporters.

Two days later, after following a pot-holed road partly flooded by the rains, we arrived at our destination. There were stewards on the spot doing an excellent job, with nearly all of the men's faces hidden by scarves. Once we got past the checkpoint into the huge, sloping stadium, we found ourselves confronted by a giant ice-rink – fifteen or twenty centimetres of liquid mud right up to the platform at the bottom where a few groups of people in traditional costume were wandering around. No-one had warned us, and we were wearing sandals. We reached a decision quickly: barefoot and with our trousers rolled up, we made our way by means of the few protruding rocks and branches scattered on the ground. Most of the participants were mountain people who had set up camp here for the celebration. Veiled expressions, sharp looks, but not hostile ones: they had certainly come for a festival, but at the same time they had an inkling that their future was at stake, with these changes of policy announced by the Deputy Commander. Would he show up himself and give a speech? No-one knew, so there was a feeling of anxiety together with real enthusiasm. People were there together, singing and listening to speeches. Although they knew about the event, there was no sign of the regular army.

And our presence in all this?

I had the distinct impression that it was almost superfluous. Certainly, it acted as an alibi, even as protection against possible attack from the air: representatives of the international press merit minimal respect. But a photographer with no guaranteed outlet for his work was really neither here nor there. We were tolerated, which was in itself quite something, but not enough to satisfy us. We had been dreaming of a certain communal spirit, and that was out of the question in the circumstances.

So we left feeling impressed by the genuine impact of the event, yet somewhat disappointed not to have discovered the exact part we should have played.

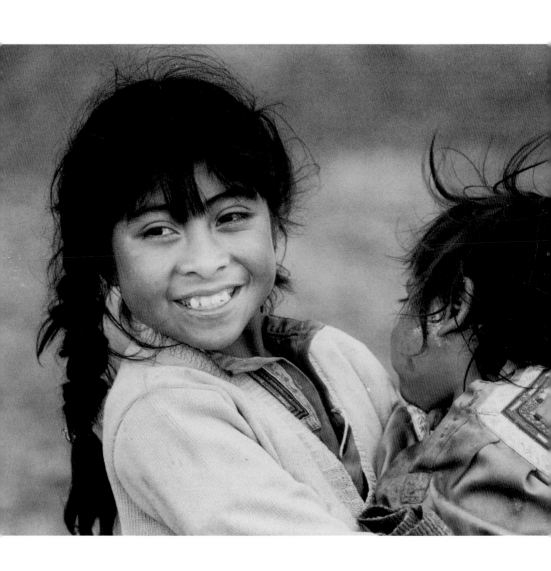

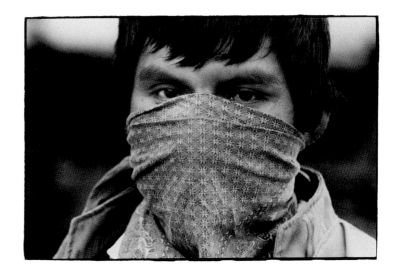

In reality, one never reaches the edge of
the world. One has to be satisfied with moving
tirelessly from one world to another.

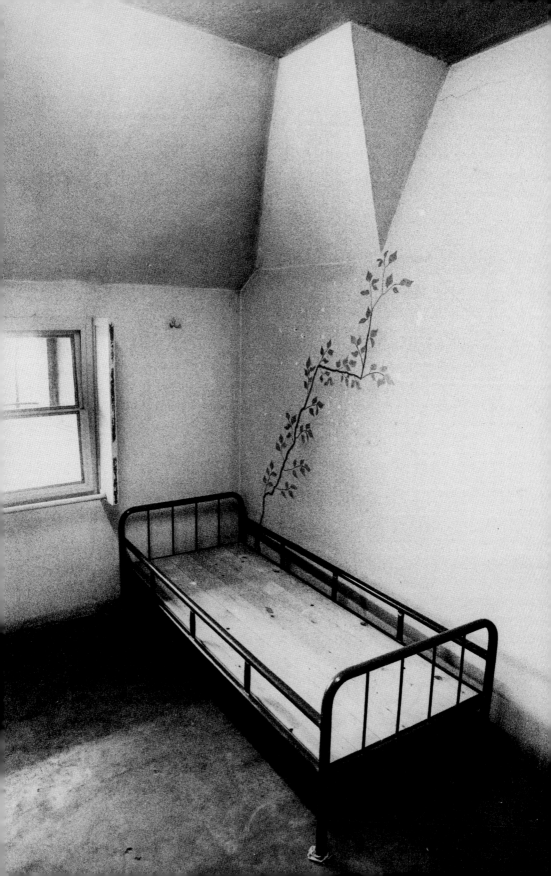